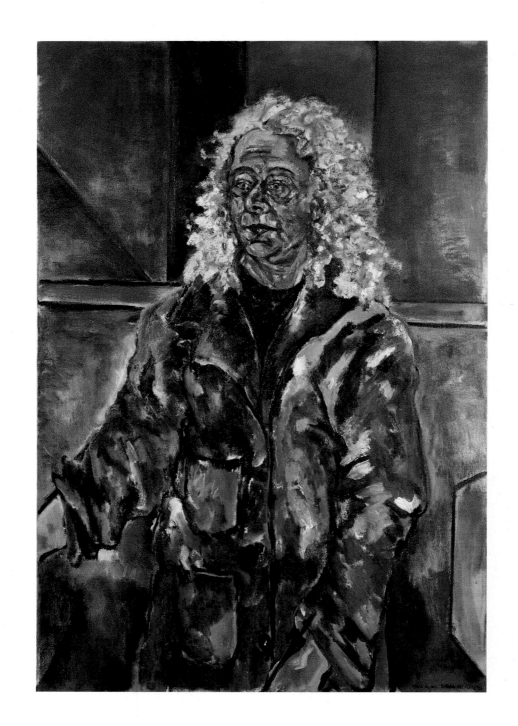

A Painter's Life
Mari Lyons

TALKS · JOURNALS · PAINTINGS

ESSAY BY JED PERL
EDITED BY NICK LYONS

SKYHORSE
PUBLISHING

FOR LARA, FINN, LINA, AND ELSA

All inquiries should be addressed to Skyhorse Publishing, 307 West 36th Street, 11th Floor, NewYork, NY 10018.

Skyhorse Publishing books may be purchased in bulk at special discounts for sales promotion, corporate gifts, fund-raising, or educational purposes. Special editions can also be created to specifications. For details, contact the Special Sales Department, Skyhorse Publishing, 307 West 36th Street, 11th Floor, New York, NY 10018 or info@skyhorsepublishing.com.

Skyhorse® and Skyhorse Publishing® are registered trademarks of Skyhorse Publishing, Inc.®, a Delaware corporation.

Visit our website at www.skyhorsepublishing.com.

10 9 8 7 6 5 4 3 2 1

Library of Congress Cataloging-in-Publication Data is available on file.

ISBN: 978-1-5107-7434-6
eBook ISBN: 978-1-5107-7441-4

Cover design by Liz Driesbach

Printed in China

CONTENTS

ON MARI LYONS

ABUNDANCE IS THE WORD that immediately comes to mind when I think about the work of my great friend Mari Lyons. She was eighty when she died in April, 2016. The paintings of Mari's that mean the most to me are multilayered, dramatic. In her cityscapes, painted in a studio overlooking the corner of Broadway and 80th Street in Manhattan, the multiplication of figures, cars, shop windows, and signage builds a cacophonous visual symphony. In her interiors she celebrates the unlikely association of objects, which can include a bouquet of flowers, an African sculpture of a bird, and a carousel horse, all engaged in a mysterious conversation—a secular version of the Italian Renaissance idea of the *sacre conversazione*. Mari was always finding new ways to fill—to energize—the canvas. She supercharged the relatively austere view of a hillside behind her studio in Woodstock, New York, with the raucous pinks and oranges of dramatic sunset moments.

Knowing Mari as I did—she and her husband, Nick Lyons, and my wife, Deborah Rosenthal, and I were a happy quartet of friends—I could see in the overflowing imagery and color of her work a hunger for a life that was full to overflowing. The great central

room in her and Nick's old modernist house in Woodstock was packed but airy, with sliding doors along one wall revealing a spectacular plunging vista, a grand, almost baronial dining table at the other end, and in between a glorious mélange of books, paintings, prints, drawings, sculptures, ceramics, and comfortable places to sit and talk. When Deborah and I stayed overnight, the bedroom where we slept was full of books and magazines that I couldn't help but want to read. Mari's art book collection was vast, an astonishment, as was her studio, with its huge central space chockablock with work new and old and several smaller rooms, also full to the brim. In Woodstock Deborah and I invariably woke up to a breakfast table already crowded with smoked fish, cheeses, breads, and fruit, much more than any of us could possibly consume. We all enjoyed the used bookstores and antique shops in Saugerties and farther afield, the chamber music at the Maverick Concerts, dinners at terrific local restaurants, especially The Bear and Cucina. Through it all, there was the endless conversation about art and literature, with Mari and Deborah, the painters, and Nick and me, the writers, composing a crazy talking quartet—which also involved lots of back-and-forth about our children and grandchildren, unparalleled among the wonders that we've shared.

Mari had a New Yorker's avidity. To watch her eagerly scanning the shelves at the semi-annual book sale in an Upper West Side library or rapidly crossing Amsterdam Avenue on the way to a dinner was to see a woman who was nourished by the city's electric atmosphere. She had that desire to engage more, experience more, know more that keeps people in New York, decade after decade. But there was also a quality in Mari—an independence, a solitude—that I believe had a lot to do with her early life in Northern California. Her father was a cattleman who married a woman from back east whom he'd met when she was in the Bay Area visiting relatives. Mari was an only child, and to the end she remained sui generis. A tall, thin woman, almost invariably wearing blue jeans, she had some of the stand-alone spirit of the West. She had a Westerner's skepticism about the trappings of official success. She resisted the East Coast reverence

for titles, prizes, clubs, organizations, associations. She was uncompromising, with flashes of the San Francisco Bay Area's old renegade spirit. She enjoyed the pageant of New York but could see through it, too.

Mari was very much an intellectual. Like many artists who respond deeply to philosophical and literary values she found parallels to verbal complexity in visual complexity. As to actually writing, it was something she did from time to time, viewing it as an ancillary activity, whether notes made for herself or the reflections on her growth as an artist and specific bodies of work that she prepared for lectures and exhibitions. The writings that Nick has collected here, some insistently private and others clearly meant for public presentation, offer glimpses of Mari's thinking as a painter as well as her efforts to understand how her paintings and her life as an artist fit into the wider world. Among many other things these occasional writings serve to remind us that a painter's concentrated day-to-day work in the studio little resembles the hyperbolic existence so often associated with the artistic vocation. There are passages in Mari's writing that bring to mind the journals of the sculptor Anne Truitt, who could not look away from life's daily demands and challenges even as she pursued something that stood apart—what Mari, in one of her notes, referred to as "something lasting, disquieting, unique."

"I have a restless eye," Mari wrote at one point. That restlessness was reflected not only in the intricacy and complexity she could bring to a single canvas but more generally in her desire to master the full range of subjects open to the artist. She was determined to be the complete painter, producing portraits and self-portraits, figures, still lifes, interiors, landscapes, and cityscapes. In her later years she even sought for a time to immerse herself in the language of abstraction, moving from floral motifs and images into nonobjective forms with an eye on the art of Kandinsky. All her work involved a strenuous, sometimes even uneasy negotiation between the actualities of the world and the imperatives of her imagination. She often alluded to Cézanne in her notes. She admired his modesty, intensity,

and singlemindedness. When she observed that "concreteness, localness may be what makes new truth possible" she was in Cézanne's territory. She also knew that she had an appetite for pageantry, fantasy, and extravagance that Cézanne, a fervent romantic in his youth, had spent a lifetime sifting out of his work. Mari was certainly aware of the tensions in her own artistic make-up. She was attracted both to modernism's astringencies and to a more baroque sensibility, and at one point asked herself: "How can I reconcile my love of expressionist art with the niceties of French painting?"

As a teenager, attending classes during the summer at Mills College, the adventuresome women's school in Oakland, California, Mari had the great good luck to study with Max Beckmann, the formidable German painter, a key figure in modernism's early decades, who spent his last years in exile in the United States. Afterimages of Beckmann's perfervid vision would always be knit into Mari's feeling for the visual world. She was emboldened by his achievement, especially the self-portraits and elaborate multi-panel allegories. "I think some of my selves," she once speculated about her self-portraits, "could hang with Beckmann and hold their own." The essential responsibility of the modern creative spirit, so Mari commented of James Joyce's later writing, was to "escape the death by ordinariness." That could also be said of Beckmann's work. Is it any surprise that there are passages in Mari's own paintings where she seems almost drunk on colors and images? She pursued not realism but what she described as an "imaginative realism that was to me more real than the objective reality of things ordered by nature." The artist's mission, so she believed, was to transform fact into some kind of fiction, what she called "the fictions that live in my studio." Reality, in Mari's work, is a riotous spectacle.

However much of artistic exhilaration can be found in these pages, there are also passages of somber and even dark reflection. I don't find it easy to read about the rejections that this considerable painter received from so many of the galleries where she hoped to find a sympathetic reception for her work. "At fifty," she wrote, "I have no fame, and only a few people have liked my work enough to want it in their homes." She felt "unknown." She

knew that she had to "work alone." She believed that "much in the contemporary world is against such a development as mine." I wonder what Mari would have felt about these very private confessions finding their way into the pages of a book. In any event, I don't think Nick has been wrong to include Mari's cries of frustration and even rage. As much as they are the record of a personal struggle they're also a reminder of the tremendous challenges that every artist faces. They bring us back to the courage involved—the trust in one's own judgment that must guide an artist, no matter how little known or well known.

That courage is grounded in the actualities of the work, in something as simple as the immense pleasure that Mari described when contemplating a new supply of oil paints, the beautiful unopened tubes promising adventures to come. She was wildly, unstoppably, epically productive. The world might not know what to make of Mari Lyons, but she made her peace with all that by continuing to make paintings—and make them, so it seemed, in ever greater profusion. Her workspaces, in Manhattan but perhaps even more so in Upstate New York, were both retreats and enchanted kingdoms. When I was with her, looking at her paintings in her enormous Woodstock studio, I felt that I was in the presence of an artistic conquistador.

—Jed Perl

EDITOR'S NOTE

IN THE SIX YEARS since Mari died, I have tried (with the help of our son Charlie) to bring order to the huge body of paintings and drawings Mari made. There were nearly a thousand of each, and many of the paintings were six or seven feet in size; Mari loved to paint large. Painting was her life; she painted almost every day and was prolific. She also left the texts of several talks she gave, several journals she kept for short periods of time in the 1980s, and notes and observations on art randomly written in her nearly one hundred sketchbooks or on scraps of paper.

She often spoke of "A Painter's Life," and I have kept this as the title of this book. As for the rest, including quotations in some sidebars, I have refrained from editing other than to correct obvious spelling errors or attend to minor copyediting matters. The talks are hers; I have only deleted a number of journal entries that were either repetitious or irrelevant to her art. In a few cases I have taken the liberty of changing a name or two.

Mari often worked in series, and often these overlapped. In the section presenting her paintings, I have kept eight of the groups she used when speaking of her work. I have taken the text introducing the groups from statements or notes she prepared for her exhibitions

or in answer to requests made by curators and a few critics. Of her immense body of work (she left nearly 1,000 paintings) there is room only for a small number of paintings here; I have tried to include some representative work in each category with a greater number of works in those groups she considered most important. All writing, in the main text or borders, unless otherwise indicated, is by Mari.

At the end I have provided a list of the museums, colleges, hospitals, and foundations that have acquired her work. Some sizes and other details of paintings are missing because they're missing.

Her recent website (www.marilyonsstudio.com), devised by Charlie Lyons, contains a fuller look at her work and various related matters.

Mari died on April 3, 2016. I hope she would have liked this celebration of her life and work.

—Nick Lyons, April 2022

mari lyons

CHRONOLOGY

1935 Born Mary Sharon Blumenau, October 27. Oakland, California, to Charles Blumenau and Beatrice Zucker—he a cattle rancher in the Merced Valley, she transplanted from Riverside Drive in New York City.

1950 Mills College, Summer Program. Studies with Max Beckmann, who has a profound effect on her.

1951 Mills College, Summer Program. Studies with Fletcher Martin.

Takes courses at California School of Fine Arts. Studies with William Theophilus Brown.

1951-'53 Anna Head School, Berkeley. Boards. Co-edits *Wanton Wiles*.

1953-'57 Bard College. Studies with Louis Schanker, Ludwig Sander, Stefan Hirsch. As a freshman, shares a suite with Carolee Schneemann. Earns a BA with high honors in art.

1954 Painting travels on World Tour sponsored by Student Information Center. Studies on "Field Period" in Paris at Atelier 17 with Stanley William Hayter, the Académie de la Grande Chaumière, and the Atelier Léger.

1955 Yale Norfolk School of Art Summer Program. Studies with Bernard Chaet and Gabor Peterdi.

Polari Gallery, Woodstock, N.Y. First solo show; receives letter of praise from Philip Guston.

1956 Meets Nick Lyons at Bard.

1957 Marries Nick Lyons at home in Menlo Park, California.

1957-'58 Cranbrook Academy of Art, in Bloomfield Hills, Michigan. Studies with Zoltan Sepeshy, Madison Fred Mitchell. Earns a MFA.

1958 Forsythe Gallery, Ann Arbor. Solo show.

July 18, first child, Paul, born in Ann Arbor. Charles, Jennifer, and Anthony are born a year or so apart over the next four and a half years.

1961 Family moves to 20 West 84th Street in New York City. Mari now pregnant with her third child.

1965 Exhibits at Granite Gallery, New York. Solo exhibition.

1970 A fire spreads from the church next door and destroys the apartment. All of Mari's early work is ruined, and most of her books. Family moves to 342 West 84th Street, renting two floors in an old brownstone. Lives there until 2001.

1975 Family vacations three summers in the Byrdcliffe section of Woodstock.

Bone Hollow Arts Gallery, Accord, New York—solo exhibition.

1977 Rents studio on West 80th Street.

1985 Landscape travels to Tunis as part of the Art in Embassies Program, U.S. Department of State.

Munson-Williams-Proctor Arts Institute, Utica. Solo exhibition and talk.

1988 First exhibition at First Street Gallery, New York. An artists' co-op gallery.

Shows approximately every two years until death in 2016. Work is reviewed warmly in the *New York Sun*, *New Republic*, *Wall Street Journal*, *Modern Painters*, *Forbes FYI*, and elsewhere.

1992 Images from sketchbooks used in Nick's *Spring Creek*, with a jacket watercolor. Additional work used in four other books by husband.

2002 After sale of Lyons Press, family buys country home in Woodstock (N.Y.), former home of Fletcher Martin, and expands his studio greatly—to 2,500 square feet, with twelve-foot ceilings and skylights. Mari does the best work of her life in this studio and loved it. During the next fifteen years travels to Montana, Rome, Madrid, London, Venice, Florence, and often to Paris, and visits all major museums.

2004 Two-person exhibition at the Windham Fine Arts gallery (Windham, N.Y.).

2006 Cityscape exhibition at the Rider University Arts Gallery, curated by Deborah Rosenthal. Talk and dual exhibition with John Dubrow.

2013 Fairleigh Dickinson University Gallery (Teaneck, N.J.). Solo exhibition.

Kirkland Art Center (Clinton, N.Y.). Two-person show.

2015 Last exhibition at First Street Gallery.

Major cancer operation on femur in October; spends 80th birthday in hospital.

2016 Dies April 3, of cancer metastatic from the breast. Buried in Woodstock, N.Y.

September. Memorial at Kauffman Hall, New York City.

2018 Bowery Gallery, *The Figure*, curated by Deborah Rosenthal.

April 1, Paul dies of melanoma.

First Street Gallery, *The Vital Street*: a memorial solo exhibition of cityscapes.

Lockwood Gallery (Kingston, N.Y.). *City/Country* solo exhibition.

2019 Sale of Woodstock house. All paintings moved to storage/studio on Oneil Street in Kingston.

2020-'22 New website prepared. Sporadic sales, many paintings donated.

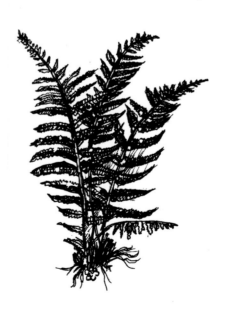

A FIRST IMPRESSION OF MARI
AS A FRESHMAN AT BARD

Mari is like a spirit, young child and deep thinker.
She is completely naïve and infinitely wise.
She is a living contradiction.

My first impression of her was that of a person whose feet never touched the ground, or if they had were repelled and took to air again. I came into my room and found her there, with piles of clothing and books and boxes. She gathered all her belongings in her arms and ran from the room, apologizing and dropping most of her stuff as she went. Later, when I was settled, Mari walked in again. I saw her as a tall, well-built girl in paint-stained dungarees. Instead of a belt, she wore a strip of cloth tied at her side. Her shirt was the top of a leotard, and at the scoop of it a ceramic medallion was pinned. Her hair was parted at the side and drawn back by a barrette. Her eyes were deep set and staring at me. "I have a lot of clothing in your bottom drawers. I'll take them out sometime." I said it was all right and that I didn't mind. My bottom drawers are still filled with her clothes. I wandered into her room later on in the day. It was cluttered with weird and interesting things: birds' nests, sunflowers and Chianti bottles, stones, African masks, sculpture and mottos everywhere. Over a desk was tacked a picture of Gandhi and a sign reading "total discipline." On the bureau another said "The way to do is to be." Over the bed one was taped that declared "Happiness is work" and a reproduction of the Shakespeare Epitaph placed nearby. —Carolee Schneemann, 1953

TALKS
AND
JOURNALS

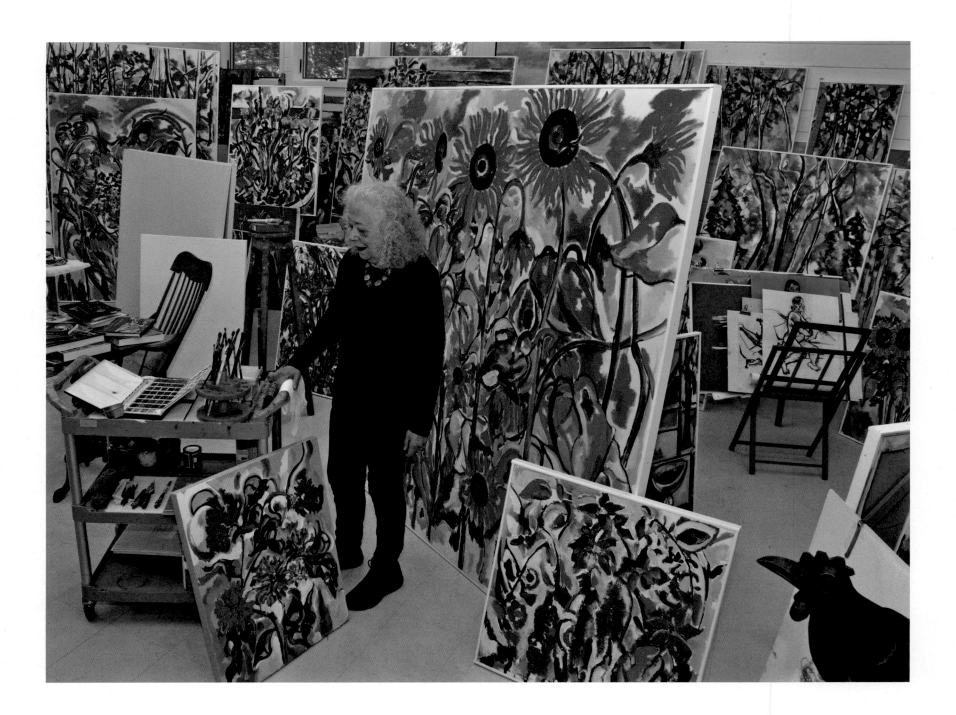

Notes on Painting*

AS I HAVE NO theories about the life I lead—I do not stop and ask a bird why he sings—I find it difficult to write about my painting. Painting is life to me: I have, God knows, many ideas about life, but I find it dismal to commit myself to any one of them. I find that I paint best when I am not thinking—that is when I am meeting the demands of the thing I am working on. Every painting sets up certain inner demands. One is constantly fighting to let the painting live in its own terms.

In September I was working on landscape—or from the landscape motif. I had been painting landscapes almost exclusively for two years and I found that I was growing more and more in the direction of destroying local image in order to bring forth a new image that I felt was natural to the painting. I felt that my landscapes could themselves be natural: that is that the painting would work, in itself, in a way that was similar to the laws that I felt existed in nature.

* Written as a senior project at Bard College, 1957. All but a few of the paintings mentioned were destroyed in a fire several years later—along with virtually all of Mari's early work.

Though my paintings at this time became more and more abstract and farther away from the objective vision that was their inspiration, I felt that they created, for me, a new reality—that is an imaginative realism that was to me more real than the objective reality of things ordered by nature.

In the fall I took long walks in the forests and I became interested in the effects of light on the forms of nature. I observed that a tree was transformed in the morning, afternoon, and evening, and actually went through a series of metamorphoses every moment of the day. Instead of painting this change, as an Impressionist, I wanted these qualities to be pointed in my paintings. I wanted the light to come from inside the paintings—or in the paint itself—and I wanted the paintings to work in the same way that nature did.

As my forms changed, so did my color. I became less and less satisfied with local color and I tried to create a new tonal quality in every painting. I felt that, though it must take many colors to create this hue, that was particular to the painting—that each painting created in itself a new color . . . a color, like an image, that was never there before. I became possessed by the intensity of hot tones and I worked toward building my images out of color planes (I was very much influenced by Cézanne). I wanted something rich and persuasive in the color itself. Color to me became form.

I worked over these eight paintings—over and over again. I felt that the thing I was after (a kind of magic that I felt in nature and in life) was simple but that this simplicity had to be arrived at through a series of organic processes.

I have always questioned the nature of the real world. It is almost as if I feel the need to make reality. As a person I love appearances: but as a painter I want to push them so that they are changed—that they are something new. Reality has usually been defined as the things that are. I want to show that it is also the things that are not, but are. This last statement involves visual paradox. It is a paradox that I cannot explain. I am, however, not much interested in the things that I can explain.

At the time that I was making these explorations into, for me, a new vision—I was also drawing increasingly from the nude. Here was a definite form that I could study. These drawings satisfied a certain need I had to check myself as I was working on my abstract landscapes. There is great confusion concerning what is meant by abstract and by non-objective. When one abstracts one is taking something away from nature (of course in one sense all painting is abstract)—abstract painting is painting that takes away from nature in order to create a new synthesis. Non-objective painting is painting that does not refer to any object. Both of these terms may be applied to the landscapes that constitute one half of my senior project. They are from motifs centered in nature, but they do not relate to a particular object as they are themselves their own object. During field period, while I was working in New York City, I continued my explorations of this kind. I was inspired more and more by the relation of the sky to the buildings which on the Lower East Side seems almost organic. I found that my drawings from the figure continued to sustain my need for definite form. Toward the end of the winter I painted several small still lifes and began the first of my compositions with figures. I cannot explain how it came about, but I am now almost totally concerned with the figure and these new paintings contribute to the second half of my senior project.

A Painter's Odyssey*

A PAINTER'S STUDIO IS an exciting place but it is also lonely, hermetic. It is isolated from what is called "the real world" and from the affairs of most people. It's a place where one goes to do that most joyous but also, I think, most difficult of human tasks: to make something lasting, disquieting, unique—that is, a work of art. So I appreciate the chance to show you my work and to tell you about the road that I have traveled to make it. I do that in the hope that I can share with you some of the joys, some of the anguish of that process. A few of the things I shall talk about are difficult to come close to, verbally—but I'll try to say them in the hope that they will be of some help to you, perhaps because you wonder what such an odyssey is like, perhaps because you already know and may appreciate that others have taken it, too.

It has been almost thirty years since I was in Bloomfield Hills with John Loy, who has curated this show. We were both in the MFA program at Cranbrook. When I got to Cranbrook I had already been painting for a long time. I started when I was about five, perhaps younger. I remember, in early childhood, staring at shapes in the stucco ceiling of my bedroom and forming them in my mind's eye as images.

*Talk given at Munson-Williams-Proctor Institute, December 4, 1985. All talks in this section have been edited to avoid too much repetition, though inevitably she repeated many ideas and events.

When I was a child, I never had a pencil out of my hands and I followed (though I certainly did not know it then) Eugène Delacroix's advice: "Never a day without a line." I went through boxes and boxes of Crayola crayons in new packs of eight, then sixteen, then twenty-four—and I think there was (in a yellow box) even one of sixty-four marvelous colors, all different. I have always loved the "things" with which art is made—the pens and pencils and brushes and tubes of paint and canvases; in those days I had only those crayons, and I broke a lot of them.

When I was seven I visited the museums of San Francisco: the de Young, the San Francisco Museum of Modern Art, and several smaller collections. In love with painting, I remember my sense of excitement and recognition as I looked at all those canvases. I especially loved the Matisses, with their vigor, their authority, and above all I can still see the ever-riveting Cézannes.

Later, when I was eight or nine, I studied oil painting, in a group, with a realist California landscape painter. Now my sense of mastery was threatened. The first day there I felt fearful, inept: I've always resisted copying; I've always had to change everything I made—just a little bit. As Matisse says: "Verisimilitude is not truth." Perhaps it is for this reason that I feel, in spite of having studied art widely, that I am mainly self-taught. We only learn what we make our own. An artist may be a person who is somehow only half-formed, who only becomes whole through the constant process of making art. Jung remarks: "The work in process becomes the poet's fate and determines his psychic condition. It is not Goethe who creates *Faust* but *Faust* which creates Goethe." The demands of realism made me struggle then, and, in other ways, the challenge of mastery has always come and gone. I think this is what Cézanne meant when he spoke—over and over, in his letters—of his struggle "to realize."

Later, I studied portrait painting with a local artist. I remember the smell of turpentine in his studio—still one of the most evocative scents to me, speaking to me of work and possibility—and the mystery and magic of the place, filled with the textured paraphernalia of art. He was a logical painter; he laid in a drawing in charcoal, put in the half tones next, and proceeded by standard academic steps toward a greater finish until the final varnish was applied. This was a process that I tried briefly but never really followed. When I went to art schools and

college it was at the height of the Abstract Expressionist period. This modernism is where I come from—artistically. As a method of teaching art it has much to recommend it. It teaches that painting is about the articulation of space, form, texture, color, and line—about a lot of things, really, but never anything that is only technique or only representation; one is always seeking what Baudelaire called "magic." Art, to teachers of the modernist point of view, was always concerned with self-creation through the development of style. Never a style, but style.

I lived near Mills College in Oakland, California, and when I was fifteen I was sent there for a summer program that included a course in swimming. Since I've never been much of an athlete, I changed my mind. My best friend, Inge Feibelman, whose parents were German, had heard that Max Beckmann was teaching at Mills, and they were forever trying to improve her mind, which leaned more toward Rock Hudson than Schopenhauer.

For several weeks I took the precaution of wetting my bathing suit every day before I went home: Yeats says that an artist must learn how to lie! The bathing suit presented no problem to my mother but she could not understand why I asked her for five dollars (the cost of a ready-made canvas) so often; I already had brushes, turpentine, and paint. It wasn't the last time I've felt the tyranny of money over art. It's a problem I still face and I've been incredibly lucky to have had first a family and then a husband who recognized my need to paint. I do, however, feel a sense of guilt; I have always been independent in *what* and *how* I've painted, quite fiercely so, but I am fifty and I have not been independent in paying for my studio and supplies. That Cézanne had money his father left him and Van Gogh had his brother Theo is no consolation. I feel not quite a "grown-up," since I don't pay my own way. Yeats says, in "Adam's Curse," that the "noisy set" which makes up the world thinks one is an "idler" to "articulate sweet sounds together"; in the end I am quite convinced that I work harder than that noisy set and that the work is my best, my only, justification.

Inge fell madly in love with an older student—Nathan Oliveira, I think—he was eighteen or nineteen and wasn't interested. Beckmann's intensity and total commitment have lasted vividly for me for more than forty years.

At the end of that summer, Beckmann, in his broken English, asked if I'd be willing to exhibit my work and I was thrilled to see several of my canvases on a wall, along with other serious efforts. He had encouraged me—usually with a nod of his head and a half smile and a "*gut, mein kind*." But what I'd learned most from Beckmann was not his generosity to me or encouragement but the chance to watch him paint. He had a studio on campus and I would perch myself on a window ledge, undiscovered, and watch him. I had only seen the cool portrait painter work, and that had been all studied technique; Beckmann painted with singular intensity and immense concentration; he seemed to be using all of himself in every stroke. Later I read and have cherished this statement of his, in a letter he wrote to a woman painter: ". . . from my heart I wish you power and strength to find and follow the good way. It is very hard, with its pitfalls left and right. I know that. We are all tightrope walkers. With them it is the same as with artists and with all mankind. As the Chinese philosopher Lao Tse says, 'We have the desire to achieve balance, and to keep it.'"

The only other major artist I caught a glimpse of at work was Matisse, while he was working at the chapel at Vence. I was fifteen and in France with a French teacher and a group of students. I'd climbed the hill alone, on a hot day, and there he was—solid, intent, high on a paint-blotched ladder . . . until I accidentally tipped over a pail of paint and he shouted for some nuns, who very seriously ushered me right out. For an instant, though, we made eye contact; his glance (I think) furious, mine frightened.

The following summer I also studied art at Mills—this time with Fletcher Martin, who was then quite famous for paintings in the Bellows genre. Martin encouraged me greatly and, at the end of that session, he also offered me a show. I remember how he taped the sides of my canvases with black tape and then hung about twenty of the fifty I had made in the Mills College Museum—the only museum in which I've had my work hung. I invited my parents to see the show and when they came in my father, who was a very large man, a cattle rancher who felt ill at ease around the art I loved, asked which of them I'd painted. "Oh," I replied, "all of them."

I learned from Beckmann not only a hunger for power but also a dread of open space.

"The feeling of love for things."

—*Henri Matisse*

To all I have learned from my teachers I add an intuitive love of intensity and color.

At Mills, Bard, Yale, in Norfolk, in Paris, and at Cranbrook, I continued to study art—and with such wonderful teachers as Louis Schanker at Bard, who taught with his hands and whose every gesture I came to understand during our time together; Léger, in Paris, speaking about the movement back and forth and around of *"l'espace"* in a canvas—it took me twenty years to understand even a little of what he was talking about; Bernard Chaet at Yale in Norfolk, who taught me to see wide possibilities in drawing, and to experience the qualities of different drawing materials—reed pen, pastel, pencil, and others. I learned—though I rarely achieved it—what a beautiful clean etching line was from Stanley William Hayter and Gabor Peterdi, though I have done no etchings in many years. Also, among my "art" teachers although they did not teach art were Katherine Backus at the Anna Head School, then in Berkeley. She would look at a group of awkward girls and cajole us to "see, think." And I am especially grateful to Heinrich Blücher (the husband of Hannah Arendt) at Bard who believed in the potential of all his students to transform themselves and find their own way as artists, as people; he made me believe in myself.

That was only the first part of my personal odyssey toward art—one that of course is still going on. There are, also, those moments when I still feel inept—that ever-uneasiness, creative anxiety. When, for example, in a life drawing group the model takes a pose I find myself struggling to capture, one that I simply cannot get right, I inwardly collapse. I visited the Musée Granet in Aix, which has a collection of Cézanne's early work; I don't think anyone—looking at those gnarled, awkward, struggling, unsuccessful efforts—could have predicted the great artist that Cézanne willed himself to be.

We came to live in New York City in 1961 and a new part of my life as an artist began. I was, suddenly and dramatically—because we are propped up and supported in a variety of ways and by a host of teachers and fellow students while we're in school—not a student anymore. I was alone. I had family responsibilities, less time than I'd ever had, little outside encouragement. I had by then two sons—and soon after a daughter and then another son. Four in five years. It was hard to keep alive a dream of art with four young children and a household to manage.

These were stressful years, joyful but difficult, as we coped with the many problems of raising children and surviving in a complex and expensive city. Through them all I painted.

And then, one icy December afternoon, we suffered a special blow.

The apartment in which we lived and where I painted was burned when a fire in the next building spread to ours. All the work I'd done until then—hundreds of paintings, drawings, and etchings—with a dozen exceptions, was burned. My art supplies were incinerated. All but a handful of our books, most of my treasured art books, were burned or destroyed by water. I remember going up to the apartment that evening, when the firemen had left, and the burned smell that pervaded everything, and the shards of furniture and books, and the sight of all those tilted stretchers on the walls, with all or most of some canvas into which I'd put my heart, my blood—torn and blackened like a raw sore.

What can you do but start again?

In our new apartment I began to paint a little more every day. I painted in the corner of our bedroom and I painted when I could. The children were all in elementary school now and after I straightened the house I'd go to that small area that had become my artistic world, and paint until three o'clock, when the troops arrived home from school. Slowly I built a new body of work. Daily I fought for an extra hour to work, and against the sense of isolation that is always the unknown artist's greatest threat. Even in recent years, when I've had a studio outside our home, there is that sense of aloneness—which is compounded by a thousand pressures, inner and outer: that you're not earning money at what you do; that it's expensive to keep painting; that other painters can see nothing about what you're doing, and often spend most of their time politicking, scrambling for success in some public mode, and ignoring the fledgling, always fragile, life of art. More discouraging than anything, I think, is the sight of such politickers succeeding in getting shows, getting prominent critics to attend their shows, getting rich friends to buy work that has been dashed off in several weeks *for* a show. You get the sense that nothing matters, that nothing *means* when outer success can be so manipulated, not by achievement but by cunning and influence.

I paint almost every day. Inspiration does not come before I pick up a brush but from the process of painting.

Though my work today is figurative, it comes out of the abstract painting I did as a student, out of the idea of a constantly evolving view of reality, out of the idea that form is not fixed but fleeting, ephemeral.

Throughout it all, while generations of twenty-five-year-olds "make it" year after year, the unknown artist takes around one's slides, seeking gallery representation. Here too the vision is threatened. Many galleries in New York won't even look at slides, and those that do often hold a sheet of them up to the light for a minute: I've seen them do so. Sometimes I think I am strong enough to accept the anonymous "Thank you" or "Not the direction we're going" that is the result of such ventures into the world. I know of no other way of doing it (though surely there must be a better one). I have had some encouragement but have known again and again the pain of rejections—more than fifty times—which is part of the profession of being an artist.

I believe that art is independent of prizes, groups, fellowships, competitions, honors, business. But, since I am human, I am ever deeply hurt when my work is rejected.

• • •

In the 1950s I painted abstractly. I returned to figuration sometime in the late 1950s and early 1960s when I felt that I needed to create a bridge between the life of forms and the objects of the natural world. American painting had come of age, had become internationally viable rather than provincial, with the painters of the 1950s—Jackson Pollock, Willem de Kooning, Mark Rothko, Arshile Gorky, Philip Guston—who all had an ambivalent connection to subject matter in art. Pollock, Rothko, and (for a time) Guston eliminated it altogether, and Gorky and de Kooning worked back and forth between a free figuration and abstraction; Guston later returned to figuration.

Though I have done a series of paintings of dancers and I love drawing and painting the figure (I do many self-portraits: I'm a free model—and I don't have to flatter myself), I have been mainly a still-life painter. The still life is an exceptionally mobile genre and of course it can signify anything—that is, it needn't be "still" at all and *any* object, I think, can evoke something that relates to animate or to human experience. I'm on tenuous ground here but—after years of still-life painting—I'm convinced that objects do have their own aura and transform the environment created for them on the canvas, either by their isolation or placement in a composition; meanings that may be hard to articulate are nevertheless implied. Somehow the objects become both the thing itself and a symbol. Thus,

Morandi's bottles are *not* people but in the magic of their combinations who can say that they are not subtly animate? Of course to be too specific spoils the mystery. I paint now from actual objects that I set up on a table. I am using a table that is highly polished and reflects shadows from the objects, so I have made use of these reflections; I have shadow and substance—the thing itself and its reflection, its abstraction.

In the last ten years my still lifes have undergone a number of important transformations. I'd like to show you a few examples from several (but not all) of the series* I have done; I paint a lot, almost every day and for long hours, and I must have made some seven hundred paintings and drawings since my fire.

The LINEAR SKULL paintings, from the late 1970s, stress my love of line; color here is more indicated and hinted at rather than articulated.

The FLOWER STILL LIFES are more painterly, even aureate; and I am working with a more agitated line.

In the BLACK VASE paintings I've shifted to a sparer, calmer image—and use a repeated, anchoring object in the black vase. These paintings are more thickly painted, even sensuously so—and I've begun to separate the objects, which are traditionally clustered in the still life.

In the TABLES group, I've dropped the horizon line, separated the objects even more, and have begun to concern myself much more with the reflections of the objects, which border on abstraction.

Then, in the WIRE MAN paintings, I'm more linear again—this time finding animation in the form of the wire man, an almost human and animate quality that I've rarely seen in other still lifes.

Most of the things I've learned from these groups of paintings are incorporated into the last still lifes I've done, those in this show; they combine or use one or more of all the elements I've been working with for the past ten years.

What I think of as a still life can be a study of space and light but also a studio interior—with gueridon, sculpture stand, and myself as a small, dim reflection in an arch-shaped Tibetan mirror.

* These or similar works are in the section of paintings.

Between these series, and as a constant exploration into other forms, I've also made dancers, where I try for a movement I've never before examined in painting. And I also draw constantly from the model, as in this nude and in these self-portraits.

I generally work in series. I find it's useful this way for me—exploring an image for twenty, thirty, or even more canvases, with as many or more watercolor or pastel or oil-on-paper sketches and perhaps monoprints of the same image, too. The preoccupations I have for one period are not the preoccupations I have for another. The impetus is continual *search*, and always the joy of, the delight in, painting. I'm not a theorist about painting and I don't write much about it. I don't even always know what I'm looking for (if I did, perhaps I wouldn't have to paint) but I am constantly changing and, I hope, growing.

In the still lifes in my show here I also use as motifs sculptures that I acquired from the studio of a deceased sculptor. The wire man, the walking figure (who changes the space by walking through the still life in the large painting *The Life of Forms in Art*), the figure of the acrobat, and the man with the wire arm are all from that sculptor's studio and were either given to me by my kind neighbors Marte and Elisabeth Previti or scrounged by me from the garbage cans in our hallway.

In some of my paintings I have been working with various forms of counterpoint; I have contrasted the "wire man" and some of the forms of the other sculptures against those of animal skulls. I have been collecting skulls for a long time. I was at college when my father, a cattle rancher, used to send the skulls to me in big boxes labeled "Bones," which mystified more than one postal authority. It's difficult to explain my fascination with these things. I don't think of them as morbid, but they do contain the muted, the natural terror associated with death—but also I think the exquisite harmonies of an elemental architecture. In me, they also evoke the primitive, the archaic, and the archetypal—and they're also fascinating pure forms, full of shadows and angles and cavities and protuberances. I like to contrast the skulls with the stuff of an inchoate art—an art not yet made (that is, the wire man, the palette, and the others).

A still life of mine is a meditation on something quiet; it is not a difference in style so much as my reaction to a different subject. I want to make of motionless objects something both still and animated.

At my studio I am now painting a series inspired by some pieces of Attic sculptures that I bought from the same estate.

• • •

My search, in painting, is not over. I feel it has barely begun. At fifty, one could say, optimistically, that my life is at least half over; well, Titian lived to be 101 and painted up to the end. I admire this, from Hokusai, on his development in art; it may give one hope, depending on how you view it—"I have been in love with painting," he says in "The Art-Crazy Old Man,"

> *. . . ever since I became conscious of it at the age of six. I drew some pictures I thought fairly good when I was fifty, but nothing really I did before the age of seventy was of any value at all. At seventy-three I have at last caught every aspect of nature—birds, fish, animals, insects, trees, grasses, all. When I am eighty I shall have developed still further, and I will really master the secrets of art at ninety. When I reach a hundred my work will be truly sublime, and my final goal will be attained around the age of one hundred and ten, when every line and dot I draw will be imbued with life.*

At fifty I have no fame, and only a few people have liked my work enough to want it in their homes. Whether by temperament or calling I just fight to keep painting—nor can I paint to meet what I think the world might like. Van Gogh, who sold but one painting in his lifetime, wrote to his friend John Russell in 1888, of another painter: "He is prompted to act in his crisis of nerves to make money—whilst painters would make pictures." That's what I do: I make pictures, and I intend to keep making them as long as I'm around. Like Cézanne, I think "the best thing to do is to work hard."

To be fifty and unknown is to work alone. Much in the contemporary world is against such a development as mine. It's hard to paint by oneself and to have little access either to the marketplace or even to the acknowledged world of art. I am, therefore, very grateful to John Loy for providing me with the chance to talk to you today and the opportunity to exhibit some of my work, to see that work out of my crowded studio and on walls, and to be able to share this work with you.

Excerpts from "Notes on My Painting"*

"**Everything is form and life itself is form.**"

—Honoré de Balzac

E. E. CUMMINGS, IN HIS famous nonlectures, says, "Lecturing is presumably a form of teaching; and presumably a teacher is someone who knows." I, echoing Socrates, only know that I don't know. I am grateful to Deborah Rosenthal—who is herself an original, magical painter—for giving me the chance to speak to you today, and perhaps clarify something of what my life as a painter has been, and is.

Jean Hélion says: "I can conceive of nothing more revolutionary today than a form of figuration that would allow the artist to sum up his whole being: what he sees and what he invents; what he remembers and what he dreams; what he is and what he wants to be. This is not realism. Realism is but the visual skin of things. It is not any more a matter of describing the world but using its endless resources. A springboard and not an end."

* Talk given at Rider University, November 2, 2006.

I begin with this wonderful quotation by Hélion because he has been one of my guides as I search deeper into a figurative art that is rich enough to accommodate all of my energies and visions and aspirations as a painter.

I now have a studio in Woodstock, New York, and one in Manhattan, and they are the worlds of my paintings, with their still lifes, figure studies, cityscapes, landscapes, and a relatively new series of Woodstock studio interiors in which I attempt to synthesize a complex group of personal images. This photo of one of eight interiors currently in progress will give you some sense of what I am doing right now, and trying to do. In this and others in this series I am using a carousel horse bought in a junk shop in Saugerties. The horse gives immediate animation and force to the canvas, and is juxtaposed, variously, with an African rooster, several cloths (which I collect and frequently use), still lifes (actual or in other canvases), at times trees outside my windows, in another version a smaller horse, this one from India, and even, in one of my interiors, myself in a mirror. Thus I am exploring the real and the not real, actual trees and trees on a canvas, real flowers and flowers in other paintings or in mirrors. I have always loved the use of mirrors in my work and once did an extensive group of self-portraits with mirror reflections. Here's one, which I call *Self-Portrait with Adumbration*, made twenty years ago. In it, I'm after some of what Picasso pursues in *Girl Before a Mirror*. Sometimes the shadows and the reflected figure, like dreams, are stronger, more potent, than the palpable thing itself. In my new studio interiors, as in the paintings like this self-portrait with mirror image, I am trying to embody the dramatic interplay of negative and positive space, push and pull, the counterpoint of disparate objects, the sense of a world ever in motion, and the energy possible in what appears to be stillness. My interiors and portraits, like an extended group of still lifes I've done, are anything but "still." In my own way, I'm trying to use some of what I've admired in such paintings are Chardin's *The Ray* where we see the dramatic opposition of the glowering rayfish, the bright oysters, and the intensely ominous cat. Not a very still still life, is it?

Looking in the mirror I am both painter and model. The canvas itself becomes a mirror—an image of the outside inside. The mirror is a metaphor for art.

In Giorgione's *Outdoor Concert*, the nude and dressed figures in the landscape, clearly an antecedent of the famous Manet, are different from what I am doing in my interiors but to my mind related in structure. And the famous *Maids of Honor* by Velázquez is a continual lesson in composition and a painting I study over and over to uncover its limitless mysteries.

Yet for all my study of tradition, I want my paintings to satisfy the needs of work made in our time; and I chiefly want to travel along my own road, working with a hand never quite satisfied with what it is making, a love of the painterly but never the pretty. I hope this art, as Hélion suggests, sums up my whole being. It has taken me many years to get this far.

• • •

Over the next seven years I studied with Fletcher Martin at Mills, Louis Schanker at Bard, Gabor Peterdi at Yale Norfolk, Stanley William Hayter at Atelier 17, and Fernand Léger (I rarely saw him) in Paris, and finally took an MFA at Cranbrook. I married at twenty-one, we came to live in New York City, and rather quickly I found myself with four children, four and a half years between the youngest and oldest, and a new part of my life as an artist began. I was, suddenly and dramatically—because we are supported in so many ways by teachers and fellow students—alone. I had family responsibilities, less time for myself than I'd ever had, little outside encouragement. It was hard to keep alive a dream of art during those stressful years—joyful but difficult—as we coped with the many problems of raising children and surviving in a complex city. Through it all, I painted, usually in a corner of our bedroom.

• • •

As a young painter, studying and working in the 1950s, I had mostly painted abstractly, thrilled and goaded by early Philip Guston and by de Kooning, and always by late Cézanne. I think it was attractive work and it had already received some praise. Heinrich Blücher and Hannah Arendt had bought a small painting and at my first show, at the Polari Gallery in Woodstock, Guston left me an appreciative note.

Then, after that early work was gone, I began for some reason to work with the seen world. I have done so for many years now, struggling to build my own vocabulary, often

In my art there is no certitude but the successful picture. That is the only academy, the only certainty.

combining genres in increasingly complex ways, though sometimes reminding myself how lovely a single image can be. "A springboard and not an end," says Hélion—using the endless resources of the visual world.

Here are some representative images from the large body of work I've done over the past twenty-five years. Most of my paintings have been in series—a way I like to work so that I can explore dozens of different possibilities in an image or genre.

In the 1980s I worked on a group of still lifes using armatures I had found in a dumpster, the residue of the sculptor Maurice Glickman's studio.

I have always sought movement in my still lifes and these objects enabled me to enlist the implied movements of the wire men and plaster maquettes. I look for objects in yard sales, junk shops, and dumpsters, and these studio castaways seemed to me especially evocative of the life of art—the incipient and the created.

My father had been a cattle rancher and at school I often got boxes labeled "Bones." For years I did many paintings in which these skulls figured prominently.

• • •

Skulls were both suggestive of mortality and fascinating in themselves, with their shapes and shadows and the whiteness of their bleached bone. At times, I combined them with flowers and a clock, striving for a modern *vanitas*. My skulls were more visceral than O'Keeffe's, less an emblem than a vibrating object. Note in this painting the thick paint I was using at the time. I can hardly lift this canvas, it's so heavy. Later, I combined the skull with figures, as in this self-portrait, which I call *Night Studio*.

• • •

For a number of summers my husband and I spent time in Montana. At first the vastness of the landscape intimidated me, but I brought a great number of watercolors and small oils back to my studio in New York and there made forty or fifty very large landscapes, some showing the vast Montana space, others the shimmering light and motion of water, some just the cottonwoods against the sky.

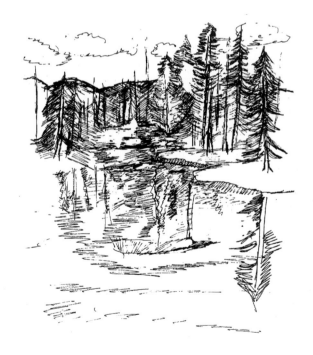

For twenty-five years I have made cityscapes from the window of my studio on the corner of Eightieth Street and Broadway, several floors above H&H Bagels, opposite Zabar's—some more abstract, others more literal. I was after the energy and texture of a city street but had no desire to do what photographs do. Some people have remarked that the cars in this series do not look like modern cars. They're forms on a canvas and they're cars to me . . . they just answer to a higher reality than Ford and Volvo. Though Seurat's painting *A Sunday Afternoon on the Island of La Grande Jatte* was important to me in thinking about painting the city, I was not after his tableau but the vitality and changeability of a specific New York City corner. Thus my *Thursday Afternoon on the Corner of West 80th Street and Broadway*, where hopefully I have caught something of the cacophony and movement of the world outside my window. *My* city, seen up close or from my third-floor window, remains ever new, and this series is ongoing for me.

• • •

I try to translate the observed into the aliveness of painting.

In the past years I have been lucky enough to have a studio in Woodstock and there, mostly during the summer and fall, my work has developed in a number of new ways.

In the front of the studio grows a gigantic oak—a symbol to me of the stability, permanence, and richness that I seek in my art. I have drawn and painted it in different seasons and I guess I see it through Cézanne. In fact, a former Warhol clanswoman named Ultra Violet visited last year and remarked, "I see the aura of Cézanne in these tree portraits."

During this period, and throughout my life as a painter, I have drawn from the model, mostly every Friday. Some of my drawings are oil on paper, some pastel on paper (I like Fabriano colored paper), and some are oil or oil stick on canvas. Degas, Matisse, Beckmann, and Bonnard, among many others, have inspired me.

The Girl with Lute combines a figure painting with a still life and studio interior.

At the Woodstock studio, which is filled with light, I have become especially involved yet again with the still life, and here are some of those I've been doing in the past few years.

The palette is bright and I like to use a wide range of objects, sometimes contrapuntally, and there is a new boldness from the use of oil stick. In my latest studio interiors, I try to combine all the various directions I am pursuing.

My work today is figurative but it's my own kind of figuration; it comes out of the painterly abstraction I did as a student and out of the many painters and writers whose work lives in me. Part of my task as a painter is to convince you—through the articulation of form and color—of the fictions that live in my studio, a place where models pose, a carousel horse gallops, and a thousand *things* play out their own music, coalesce, and are reinvented on my canvases. In my art there is no fixity, no certitude but the successful picture I struggle to make—though of course I am rarely certain of that either.

At my current age, I am more in love with painting than ever. I paint almost every day and, for me, inspiration comes from that process. Like Cézanne, still my master, I think *"happiness is work."*

Henry James says, in "The Middle Years": "We work in the dark—we do what we can—we give what we have. Our doubt is our passion and our passion is our task. The rest is the madness of art."

I concentrate on a subject and it changes; as I proceed I see new combinations, new directions, new possibilities. I work in the dark, always seeking light, and there is never enough time.

Through the articulation of form and color, line and space, I want to make something more lasting, more real than what is called reality.

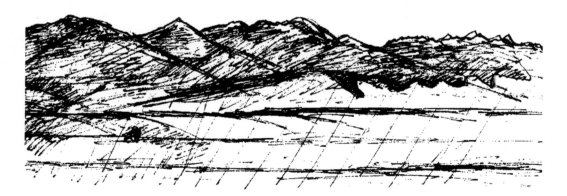

Notes on a Cityscape Show[*]

"The signs come at us from many directions; they color the people next to us in complex blends, and we become colored, too, all of us overlaid with the moving lights and shadows. We metamorphose as we turn around, and we have to turn around to make any headway in this crowd."

—Marshall Berman

DRAWING IS THE ARMATURE of my life as a painter. This has been so from the first uncertain lines I drew as a five-year-old. And it was so when I was fifteen and studied with Beckmann, and throughout my years of study at Bard College, Yale-Norfolk, Cranbrook, and the Grande Chaumière. It was so when I painted abstractly, and it is still so, as you can see in the work on the walls of this little gallery.

Drawing has been the bone and superstructure, the axis on which all my work turns. Like Ingres, I think, "Drawing is the probity of art."

The visual world provided endless forms and ideas. Abstraction limited my possibilities. Drawing released what I saw and gave my subjects the forms my canvases demanded. I felt no obligation to the things themselves, only a gratefulness that they had been there, in their infinite variety, to instigate the canvas in front of me.

I want people to look at the canvases as worlds they can enter into—*real* constructs with imaginary cars in them, to paraphrase Marianne Moore; as such, the reality of the cars does not depend on verisimilitude.

[*] At First Street Gallery, 1998.

I want the energy and complexity of a city street but I really have no desire to represent it literally, which photographs can do better.

I feel an urgency to make of the things outside of me something that corresponds to something inside me, and is aesthetically satisfying. What I see is the changeability of a specific New York City landscape: the seasons change and bring changes to the trees and to the islands in the center of Broadway; shops change more frequently than one would suppose; and of course the daily traffic of people and vehicles is different moment by moment. The street can be hectic and irritable, calm and domestic.

• • •

I like to paint in series, so I can explore dozens of different possibilities in an image or genre—still life, landscape, self-portrait, figure drawings. In each, drawing is at the heart of the work, and remains of the greatest importance to me—and I draw from the model every Friday for three hours, religiously.

I paint almost every day. I don't think I'm at all conventional. I respect deeply Braque's statement that "the only valid thing in art is that which cannot be explained. If there is no mystery there is no poetry—the quality I value most in painting." It's one of the qualities I too value most.

But for myself, I try to travel wisely along a road very much my own—seeking the underpinning of a drawing hand never quite satisfied with what it is making, a love of the painterly but never the pretty, a vision that is neither figurative nor non-figurative, an art that can somehow use the great achievements of the past—abstract and figurative—yet be my own in every important respect. I constantly seek a new knowledge and authority that, I strongly suspect, can be best found in drawing, particularly from the human figure.

And in this show, a sampling of the large canvases I have made in recent years, the late stages of a long process, I am trying to create a world on canvas that corresponds to the life of a great modern city, seen through the particulars of the Upper West Side of Manhattan.

"Something must remain open, unfinished, not fully executed, for my painting to be right."

—Jean Hélion

My ambition has been no less than that of all the painters of cities who have come before me: El Greco, with his brooding yet triumphant Toledo; Chagall in his entranced transfigurations of Paris and Vitebsk—where he found light and freedom not found anywhere else; Kokoschka with his cosmic panoramas; John Marin, Fairfield Porter, the Delaunays with their ever-recurrent Eiffel Tower; the German artists August Macke, Ernst Kirchner, Carl Manse; in France, Degas, Monet, Pissarro, Jean Hélion (late work), of course Seurat; and others, all of whom investigated the motif of the street. But New York City in the 1980s and 1990s is a very different world. The city is a subject and a symbol, a source of objective and subjective power and suggestion.

To me, it is endlessly fascinating.

My Broadway is a tapestry of movement.

My street is about many things; perhaps my man with a briefcase echoes—in some way—Cézanne's single standing bather at MoMA. I've felt that this figure's aloneness was a metaphor for the isolation of twentieth-century men and women. The street paintings also take up the old theme of the figure in the landscape. I've painted the isolated figure dominating the picturescape and the small groups of figures lost in a larger space.

I'm always searching. I see in the street theme—the idea of the street—a metaphor for my life as a painter in 1998.

Excerpts from Recent Work***

I'M GRATEFUL FOR THE chance to talk to you about my painting—but since I'm more accustomed to painting than talking about painting, please excuse me for reading these first remarks.

Afterward, I'll show you two short videos made by my son Charles in my studio—for which I did not use notes.

Max Beckmann once wrote to a young painter that she should "learn the forms of nature by heart, so you can use them like the musical notes of a composition. That's what these forms are for. Nature is a wonderful chaos to be put into order and completed."

This is some of what I have been striving for in my recent paintings: I am abstracting natural forces, or signs—born from my observations, of growth and the processes of becoming in the natural world. Gardens have been fruitful places with which to begin

I want to show the metamorphosis that exists in nature—in the flowers' stems, leaves, shape, colors— one thing morphs into another and this golden mobility gives birth for me, to another aspect of mortality.

* Talk at the Woodstock School of Art, August 29, 2013.
** Videos available on www.marilyonsstudio.com.

and I have tried to translate my responses into the language of painting. Parts of a flower (stem, leaf, petal) metamorphose into archetypal images. Circles, which are so common in nature, predominate, and I have been trying to make paintings that in their entirety pulsate with a life force. I have tried to find in the natural forms, parallels—in color, form, structure, and line—to the dramatic energies in nature and to the constantly mutating life of forms.

When I visited Fletcher Martin in Woodstock while I was in college, I was making abstract paintings—it was the time of Guston, de Kooning, and Pollock. Later, I shifted back to figurative work and worked in that mode for nearly half a century—at Byrdcliffe houses we rented during summers when Nick taught at Hunter College, in a city studio where I painted a great number of cityscapes, and then here in Woodstock, after we bought Fletcher's old house, expanded his studio, and began to spend half the year here.

My studios—here and in New York City—must look like a jungle of images. I am an everyday painter and I have scores of paintings from each of the dozen series I've explored. Often, as now, when I am preparing for a show, I'll have as many as a dozen—mostly large—paintings on easels. I like to do what I call "Bonnarding," after the way Bonnard often worked on many paintings at once; I "Bonnard" mostly with paintings I had thought complete—one speaks, another doesn't; perhaps an area needs a few more strokes.

Painters today have a fecund resource: the entire tradition of painting—the vision, perceptions, achievements of painters from the Lascaux caves to the immensely varied work being done today. We truly have Malraux's Museum Without Walls and can learn from, ignore, or reject what we find. Authentic individual vision can only be built upon love and admiration for the best art of the past, but it must be digested and transformed into a personal vision. You take what you can. I love Rembrandt, Cézanne, Poussin, Kandinsky, Titian, Braque, Velázquez, Corot, Piero, Giotto, Picasso, Matisse, Tintoretto, Giacometti, Bonnard, El Greco, Goya, Chardin, and many others—too many to list but all, always, part of an ongoing dialogue I have with the past.

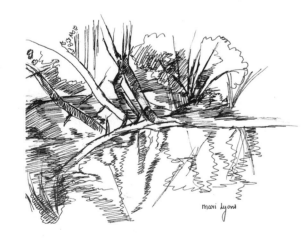

mari lyons

I am restless as a painter. I want to have it all—figuration, abstraction, the genres and non-genres. I need my own personal language, so I am constantly changing—wanting not a particular style but "style."

Some of the directions I have explored recently are:

A series of pastel drawings and oil paintings made directly from the model—which I have done regularly for many years.

Landscapes as the motif in Woodstock and Montana and out of the window of my Woodstock studio.

Large cityscapes.

I've done innumerable still lifes from setups in my studios—of all sorts of objects, including sunflowers, fruit, animal skulls, musical instruments, and much else.

I've done portraits that attempt likeness and a good number of self-portraits.

Several years ago I did a series of complicated studio interiors that included a carousel horse, tubes of paint, mirrors and the objects reflected in them, other paintings in the studio, new and old, my palette table, and much else, melding the complex scene, which even included the outside coming in, into a whole.

My last show was of hillsides and sunsets and carried more abstracted sections as I strove to bring increased energy and passion into the work. Now I have gone even further and am attempting to abstract from the things in my garden—real and imaginary—and to make paintings that may borrow from Cubism, classical abstraction, and much else, paintings that come together as a kind of personal painterly abstraction that, I hope, is mine alone.

My studio is alive with hope—that the next painting will be more successful than the last, though the new one proceeds from what went before. Good days, days when nothing works, days when (as Henry James says) we truly "work in the dark."

I'm never entirely sure where a canvas will take me next, what *it* will need—whether I can fully join my *Thinking* and *Emotion*, the total commitment I make to find my way in the language of painting.

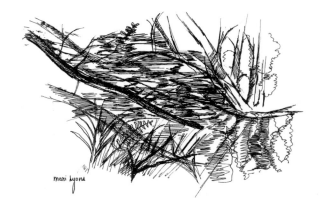

mari lyons

In my many hillside paintings I try to record the changing quality of light, the transitory sunsets, the relationships of positive and negative space, and the inherent metaphoric content of an enclosed space, a microcosm. Events happen. Trees fall. They leave a skeleton of branches; trees become animate and are never the same. The sky breathes with a mysterious glow.

Though the studio is separated from what people call "the real world" I enter armed with thoughts from some of the painters I love:

Odilon Redon says: "It is precisely from the regret left by the imperfect work that the next one can be born."

And a thought from Braque: "I am far more concerned with being in tune with nature than copying it."

These ideas and many more words and images are with me in my crowded studio as I try to find my way.

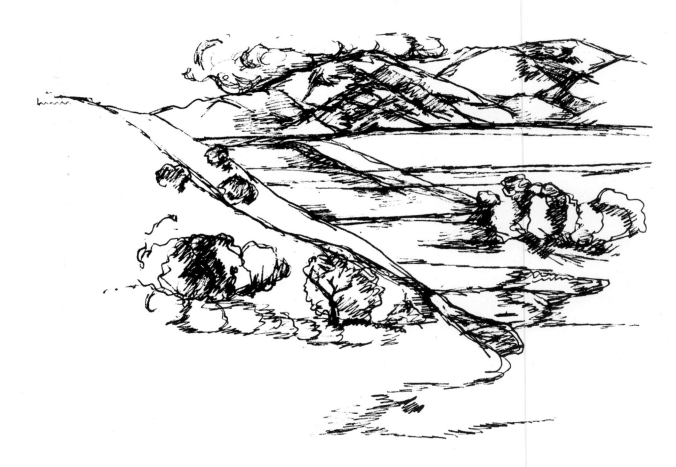

From the Journals*
and Sketchbooks

1978

8 May: Beautiful shadows thrown by the light on the windowsill. It's always difficult to determine the color of a shadow.

15 May: Economy. I'm not much good at it in life—or in Art.

One brings to the studio one's worries, fears—anxieties. It should be possible to use everything one is, in art. The trick is to know oneself, to know one's positive parts, to know one's weaknesses and to be able to use this knowledge as part of one's equipment.

28 May: Madness everywhere. On Broadway a man thinks he is a duck . . . quack, quack! How well I know how hard it is to find within oneself the inner harmony necessary to make Art. Sometimes it seems almost impossible—after a carping fight with Nick, the children.

5 June: What is the meaning of my series? Is it to explore what it means to make art? How trite. But is it a mystery? Why do some people love the movement of an arabesque on a canvas, feel the tension of color juxtaposition? When I was fourteen, I painted a plumed

* Excerpts from several journals Mari kept only for short difficult periods in the 1970s and 1980s.

bird, caged—with black outlines like Max Beckmann. In some ways a studio is a prison. It protects one from life, at the same time it keeps one out of the life of affairs, busyness.

20 June: It's been an odd month. Ill health, my mother's visit. It's hard to hold to one's center. But I think today that I finished (or nearly finished) my large painting. It's like a battle over, though victory is always incomplete and one is inwardly never sure whether one won or lost.

22 June: I sat looking at Margot's work today. Her fine talent allows no mistakes. She probes everything as far as she can and settles for no easy way out.

26 June: A new canvas on the easel. I always feel afraid to jump in. I well know that what I do in the first half hour will determine the course of the entire painting. I would like to make huge strides, to create a new space, to intensify my color—to make color sing. But one does what one can, a step at a time . . . slowly, slowly. Color, what a mystery it is . . . in spite of all the theories. I remember years ago a cocky teacher pointing to areas on my canvas: "These are colors. This is color." I wish one could be so sure.

1 Aug.: Again. I always have the feeling I have not found my way. Should I move toward the abstract? Would I not then sacrifice the specific? Concreteness, localness may be what makes new truth possible. Certainly one cannot take another's way.

14 Aug.: Weeks since I started the Broadway painting—still no real progress. Yet I persevere.

24 Aug.: What I am after in my painting is truth, spiritual truth. It's a truth born of a connection with a model, a scene, but mysterious, elusive. It's the kind of truth Velázquez displays in the *Maids of Honor* and in *Juan de Pareja*, Titian in the portrait of a young man in the Frick, Rembrandt in his self-portraits and in so much else. What equipment do I have to reach such heights? I don't know. One works. Certainly connection is still possible and now and then a little insight.

28 Sept.: Tomorrow work on Susan's hands, face, feet. Try to clarify the composition.

**"We do not know all the colors.
Each one of us invents new ones."**

—Guillaume Apollinaire

13 Oct.: Began birthday self-portrait . . . made the head larger than life in order to emphasize its importance. So far I am nowhere in it. But, I'll work. It's my intention to paint a self-portrait now every year—near my birthday.

25 Oct.: Still working on birthday self-portrait. Began portrait study of Susan—riddled with problems. The first strike (the first two hours or so) are crucial. The rest of the process is in correcting those initial errors.

26 Oct.: In a discussion with Penny we talked about the difference between painting and drawing. In drawing, even a finished drawing depends on—or one takes for granted—a completed background, i.e., the paper. In painting, blank canvas can be left but the thought must be created, articulated completely.

I would like to preserve the sense of excitement that is possible in drawing in my painting while, at the same time, finishing the canvas. The thing to do is to allow the forms to emerge in the "right" way. Alas, one might achieve this by applying a uniform ground—as in most early painting—or by painting the canvas black, as sometimes does Francis Bacon.

1 Nov.: I finished my birthday self-portrait. What started out as a masterful statement ended as a portrait bathed in anxieties. I saved it, if it's saved, by a certain richness of color.

Contemplating new canvas. I'm thinking of something with the Florentine vase and gladiolas.

3 Nov.: Still thinking about a large, new composition. At the end of the week, not much accomplished.

8 Nov.: Started a large composition with three gladiolas. I feel uncertain as to what I'm doing, but always there is that excitement of starting, especially on fine linen canvas. It's as though something is bursting into being. I feel pulled in so many directions. I want to do so much. In the background there is Nick saying, "Simplify, simplify" and I feel he is right. How can I reconcile my love of Expressionist art with the niceties of French painting? People are the

greatest subject. But I must, of necessity, do so many still lifes—the only subject always available.

Try to get the emotional intensity of *View of Toledo* into the Broadway scene. Jennifer read me a quote (I think from Emerson): "Every object rightly seen unlocks a quality of the soul."

20 Nov.: It's easy to work well when inspired, encouraged. Try to concentrate, to wrest from jealousy, pain, new forms, new inspiration.

25 Nov.: Try to use big forms and keep things uncluttered. Keep colors limited.

8 Dec.: A very hard couple of weeks—envy, inability to work, depression. I must do something totally new, bold. Alas, how can I get free?

1979

4 Mar.: Think of the beauty of a falling cloth—the form made elegant, complete.

17 May: An amaryllis quickly to be caught. So soon inviolate.

20 Aug.: Richness of color—to create richness of form.

1980

2 July: Remember richness of surface—never mind a certain primitiveness which occurs over and over again in the self-portraits—but seek larger forms. Always remember that if one paints with passion—the passion will carry it. Try for a shimmering quality which will relate mass to mass, tone to tone as in Cézanne—something a little oriental.

6 July: Remember—to leave out! To do: large nudes on two of the 78" x 84" canvases.

Mostly 1981 and Later

27 Oct.: Saw Allan Frumkin. He said there was "something" about my painting that he liked—but not enough evidently. He said my looking for a gallery was not hopeless. I would

just have to find somebody who was really wild about my work: I felt hopeless. Somehow he left the door open for me to see him again. I then, after trying Alex Rosenberg ("send slides with S.A.E."), Hamilton ("bring slides with S.A.E."), left my work at Blum Helman and returned to the quiet studio.

28 Oct.: Late afternoon: I picked up my book at Blum Helman. They said, curtly, "Thank you." Not one slide seemed disturbed. I went across the street to Marilyn Pearl. ("I'm sorry. We are not looking.")

Haber Theodore (said he wasn't looking but looked—said he liked the dancers. Not enough, I guess).

1985

3 Apr.: Anthony returned! He looks wonderful and he brought me Foinet paints—lots of cadmiums! I put in an order for canvas at David Davis.

4 Apr.: I have not yet found a canvas to paint over. I'm trying to at least hope that someday I can show my work.

5 Apr.: I want to do something on paper—something that will lead me into a new kind of space—simpler, freer.

7 Apr.: We went last night to see Glenda Jackson in Eugene O'Neill's *Strange Interlude*. What a joy to see live theater—one's eyes move, one strains to hear; very different from the movies—where one's senses are dulled asleep. I went to some Madison Avenue galleries today. I discovered the Claude Bernard Gallery.

8 Apr.: I've had a slow start for the day. I covered an old (4' x 5') painting of the model Janet first with acrylic sienna and then Maimeri Oil Vandyke Brown.

Received an order from David Davis; it always brings a combination of joy (new blood) and despair (money spent with no—or very little—hope of ever selling anything).

9 Apr.: I'll try to finish the study I started yesterday. Didn't leave studio until 8:55 p.m.—not much work though.

11 Apr.: I'm finally off to pick up my slides at Einstein (a certain rejection). I'll never be able to deal with so many rejections. Jennifer Bartlett's show was raved about by Michael Brenson. I quote this: "Bartlett starts out with a post-modernist doubt about absolute originality and the existence of the self . . ." Maddening. I'll try to see Caravaggio.

13 Apr.: Henry [a studio neighbor] is here—after an absence of six months. An air of polite hostility? His dog came with him. The dog always sniffs my bones. John Loy, from Cranbrook, says that he may be able to arrange a show for me at the Munson-Williams-Proctor Institute.

14 Apr. (a Sunday): I am determined to finish my last painting—skulls and wire man.

15 Apr.: A dark day—raining. Is my work any good? Am I going in the right direction? Oh, well, to work. I read a little of *The Painter's Mind*, the Bearden-Holty book. I couldn't get into it. Making is always more exciting.

16 Apr.: Laura Westby is to come today with six new stretchers. I'm thrilled—new hope! I intend to start a new canvas (over one of the outdoors-indoors series).

17 Apr.: I got in early—wrote a letter to John Loy. I must pick up slides from Findlay tomorrow. I'm out of so many colors. I'd like to see the Marquet show at Wildenstein. Why is painting always so slow—and why are there so many doubts? Should I have this skull and palette series photographed? Is it a waste of money?

18 Apr.: Took slides to Claude Bernard; I'd love to show there. It's hopeless I think. I also saw shows of Resika, Bartlett, Clemente, and Harry Soviak—an ex-Cranbrookite who died recently. I bought supplies at Pearl Paint. I'm bushed.

19 Apr.: I'm working on my three-skull painting; it's coming on despite rain and thunder and unusually hot temperatures. I'm determined to start writing a piece on painting.

20 Apr.: I can see that I *must* give up my studio. Nobody wants me to have it. I am so totally alone. I have no friends.

22 Apr.: I cried most of the night. Nick has IRS problems again and tonight we meet with the Levys about our rent. I can hardly bear all of this tension. My studio is slipping away. I've tried so hard.

23 Apr.: Bad day. I started an oil on paper of two skulls—odd angles. I'm not sure it will work. Nick made an agreement with the Levys to extend our lease for two years. Does this put a limit to our tenure in New York? I can't live in New York forever if it means Nick has to have two jobs. I feel impermanent. Tonight I'm off to the Metropolitan Museum.

24 Apr.: Every day I'm painting is a good day. Henry had a model. I'm so jealous. But I must remember that real painting must be done alone; it must be one's personal vision and I have art history in me.

25 Apr.: Henry was in—late—and he had another model. I will have to learn to overcome jealousy. The main thing is that I am able to work. He came into the studio for a minute, with the model. They both seemed to see nothing. Are my paintings invisible? Confidence: I must just have it, against all odds.

28 Apr.: I read stories from *Dubliners* and could understand fully why Joyce exiled to Paris and wrote novels of such linguistic and iconographic complexity that few can follow him and some of his meandering. He wanted to escape the death by ordinariness.

30 Apr.: I picked up my slides at the Galerie Claude Bernard. They asked for my name and address—I *hope* that's a good sign. I saw several Madison Avenue shows, including some beautiful Matisse drawings (better than the ones at MoMA), and a show of Susan Rothenberg's; her work has some interest for me—but at this point nothing satisfies me but my own work—and even that, not always. Also saw at Wildenstein—a show of Albert Marquet—a happy talent, but it's interesting that he never progressed. —As

did Matisse. Still, some of the landscapes are luminous—especially the harbors. The nudes are bad.

2 May: A slow day—working on this and that. I hear voices from the neighboring room: Henry has a model; it's a party and I'm the uninvited. I don't believe that all the encouragement or all the models in the world will ever make Henry an artist—but who knows.

3 May: When will spring really spring? I must draw more. I did some sketches of Rubens' painting of Caravaggio's *Entombment*. Each drawing inaccurate, each different—spaces different. There is something about me that avoids exactitude.

5 May: I went to the Guggenheim this morning . . . Gilbert & George. I *hated* the exhibit's photographs. But I found sustenance in the permanent collection.

This afternoon I painted out the Venini painting and one of the ballet series.

It's hopeless. The studio is too crowded. Oh, I could use some encouragement.

6 May: I removed my little paintings from Marvin Gardens. I felt so sad. I'd have loved to have sold something. I sat catatonically most of the day.

7 May: I made an appointment to have slides made. It will be a big job but I'll have new hope, new slides to take around. Tonight I go to the Met.

8 May: I worked on the 40" x 74" three skulls. It's a bit muddy but I took it off the easel in order to strike a new canvas. I want this one to be like a crucifixion—strong contrasts—black against white. I'm nervous. My chest hurts. Creative anxiety or chest pains—I don't know?

9 May: I visited several galleries in SoHo—dismal. Not much work today but I have to paint.

10 May: I bought a few books at the Library Fair and started to paint over the Venini painting. It's an unlucky canvas—an awful start. I'll keep working.

11 May: I worked a few hours in the afternoon and had a glorious call from Nick. Would I come home and play. I went.

14 May: Worked on the painting over the Venini. I'm still not getting to it. I read some of the Gombrich, *Art and Illusion*—interesting but I'm not convinced Gombrich understands the mystery of personal, individual style. Interesting to think of Jennifer Bartlett in terms of Gombrich.

19 May: There was a shocking lead article about Jennifer Bartlett in the NY Times. John Russell let his passion overcome his acumen. He says she never trolls in the gutter for a cheap effect, never politics, works 12 to 14 hours a day. Her only faults are those of a generous spirit. Unbelievable!

21 May: Nervous. I broke the blue vase in the studio kitchen.

22 May: I picked up slides at Fourcade—a cold beginning for my new slide circulation. I started with so much hope for these new slides. The receptionist gave the slides back with only this comment: "Oh, I'm sure he saw them." I was not. I finished the painting over Venini.

23 May: I started a painting over the white ballet painting.

24 May: Picked up slides at Hirschl & Adler Modern; no comment. The girl at the desk—eyes down—said they had been looked at. The director "did not have time to enclose a note . . . ," she added. "It was a form note anyway." The girl at the desk at Willard said that Ms. Willard never said anything. "If she wanted to get in touch with you, she has her ways." Voodoo?

25 May: The Naum Winers gave us tickets for the ballet; it was a great treat—and so much to learn from the counterpoint.

27 May: I spent an hour going over my art expenses—1983, 84. Heartbreaking.

28 May: A totally awful viewing at Frumkin. He gave me a dirty look, as if to say, "Can't you get lost?" A young assistant looked at my slides with a fancy new viewer. He said he was not interested in my paintings—that I was "uninvolved in the still life." Uninvolved? He said he "couldn't feel it."

The interviewer at the Art Information Service cheered me by saying my work was as strong as that showing at Knoedler and Graham. His solution: "Politic." Yeah!

1 June: We went upcountry and I bought a mounted cow skull at a tag sale and a small easel.

2 June: Did a pastel of the mounted skull. Only fair. I want to get to where the image and icon become one.

3 June: I looked at Lovis Corinth's portraits; I see Rembrandt's shadow and yet a real persona.

11 June: I finished, in oil, the self-portrait study I did yesterday. It's fair. I'm restless.

I am constantly becoming myself.

12 June: Worked on the self-portrait. Why do I always have such problems with self-portraits? It's always an act of self-creation.

13 June: I went shopping at Pearl Paint. I spent over $200. My hand was shaking when I wrote the check—but, oh, what wonderful paint.

14 June: I might get the casts from the antique owned by Mrs. Glickman. They would furnish me with images for years.

15 June: I did an unbelievable thing. I bought (for one hundred dollars) the Attic casts from the Glickman studio. Am I mad? With the wolf at the door!

19 June: For me a self-portrait is an act of self-creation; it has less to do with seeing than with becoming, making.

26 June: We were in Vermont for three days. Back in the studio I am full of energy—for work! I did some sketches of the Elektra torso. I am so glad about those Greeks.

27 June: Annette Oko called and told me to remove my painting from Teacher's. I'm rejected—even from a restaurant. Why?

28 June: I finally got a form rejection from Soho20. Could everyone be wrong about my work?

3 July: I feel at ENDS. I'm in my studio, which I love, and nothing much is happening. Is my life on the brink of collapsing? I'd better hang in there and work—while I can.

11 July: Nick got (miraculously) let off by the IRS. I feel a big weight lifted from me. I'm still not untroubled enough to give up smoking—but almost. I feel in my work on the verge of something new. But it comes so slowly.

22 July: Hot. I'm back in the studio. Can I work with all my wars (inner and outer) going on? I must try. Salvation is mostly through work.

24 July: That new large canvas (78"x 98") must be a masterpiece—the best I am capable of. I must think and think. The Greek sculptures curiously have the same archaic quality as the skulls; they all approach the archetypal. They are hardly individualized.

25 July: Michael Miller came and bought a pear drawing. How lovely to sell something—even for $150!

Michael and Mary—bless them—liked the skulls and wire men. They saw the connection between the unfinished symbol of Art (the wire man) and the eternal, archaic quality of the skulls.

27 July: I walked all over town this morning. It was a cool day and I delighted in being out and about. On Madison Avenue I saw a fair show of Egon Schiele. He had a great line but the paint is ordinary. Worked in the afternoon.

29 July: I worked on the two columnar torsos. They are becoming an obsession, and still I can't get anywhere with them. The heat is debilitating.

1 Aug.: I started the big painting; it's about the worst start possible. What is the matter with me this summer?

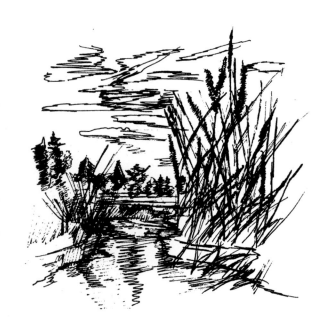

2 Aug.: I still worked on the columnar paintings; it was another slow day. The large painting is beginning to come.

4 Aug.: I went to the Met and looked at Beckmann, de Kooning. There were two new Lovis Corinths in the nineteenth-century wing. The later one, after his stroke, looked like my work.

5 Aug.: I've been working on the big Greeks. I want so much for this canvas. I want it to be free, abstract, taut, real, and to hover into a territory I've never achieved.

7 Aug.: I know that my days of coming to my studio every day are extremely limited. How can I go on painting paintings that nobody wants—and at this expense; it's absurd. I wonder if I've given this all I could? One could always do more. One longs for those long days that are non-existent.

Excerpts from "Studio Journal" 1993

8 Jan.: I just came in to wash brushes. I intend to work on a "special edition" of Nick's *Spring Creek*. Doug Ewing will pay for this. Nick, who saw the book last night, liked my adding watercolor to the illustrations and wants me to make one for him. I'll be in the *Spring Creek* business!

11 Jan.: I bought more paper at Menash. Tonight Steve Brennan debuts at the Public, and Anthony returns to Albany. I'll miss him.

12 Jan.: I bought a portfolio at Menash and reworked the two small versions of *In the Studio*. It's been a year now—and they are still not right. Still—I think things are beginning to go.
 Tomorrow: buy freezer paper for palette—rubber gloves—garbage bags.

13 Jan.: I can't wait to go to Montana . . . it's such a long way off . . . a gray day today. I bought some flowers to do a study. I hope Anthony is all right. Albany must be bleak.

15 Jan.: I'm going to the opening of David Rich's show tonight at First Street. I'll do another flower study—as the flowers are holding up. Mark came by. He didn't respond too much to the paintings.

16 Jan.: I'm feeling old, I must learn to move (in my painting) with more force, certainty. I don't have time to retreat.

17 Jan. (Sunday): We went to the flea market at the schoolyard and I bought several books—including one on *Degas in the Art Institute of Chicago*. This book collecting is becoming a mania. I'm going to clean brushes, write to Paul, and do a drawing of Jennifer and Steve—for their wedding announcement.

18 Jan.: Mortality is all over. Nick told me that Peter Hammer has cancer.

I bought some more art supplies at Menash, including a Number 5 Winsor & Newton watercolor brush.

19 Jan.: I spent much of the afternoon working on some sketches of Jennifer and Stephen to be used in a wedding announcement. Everything takes me so long. I hope I can get back to painting tomorrow.

20 Jan.: I went downtown to have lunch with Nick. Flax was having a sale but there was very little there to buy. I bought a small plastic frame and some mediocre brushes.

21 Jan.: I got to the studio early—11:15—today. I can get into some painting.

I spent most of the day rearranging the studio; it's a mess. Finally, late in the afternoon, I pulled out an old canvas in the dancer series to repaint. I hated to give it up—but I need something to work on. I have no idea where to go on this. I just need to get into some work.

23 Jan.: I went to galleries with Nick. We saw John Walker's work at Knoedler (beautiful paint, about nothing) and Lee Krasner's umber paintings at Robert Miller (I believed them better). We also saw some cheerful, vacuous, mostly small (house size) paintings at André

Emmerich, by David Hockney. Finally, at a gallery adjacent to Emmerich we saw a small show of Morandi; he seemed—in those tiny spaces—a *giant* compared to what we had seen—anyhow it's *real* painting.

24 Jan. (Sunday): Nick and I went to the Fair at the schoolyard. I bought some good catalogs.

I just struck an underpainting over the large Dancers that I pulled out Thursday. It feels wonderful to be working on a large canvas again. Things are starting to move—a little. I struck the big one with Carl's voice rising to an irritating crescendo; he is renting a nearby studio and has company, I guess. I tried to drown him out by playing the radio—very loud. He doesn't know that I exist: the jerk. I think the theme of these last few canvases might be "shadow and substance"; it's one of my old themes—but this may be a new slant—something articulated, some things not defined (some shadow shapes, evocative). A continuation of self-portraits with adumbrations.

25 Jan.: Now to work on the large canvas. I bought at the Fair a deck of Tarot cards. I may be able to use some emblematic motifs. I called in an order to Williamsburg Paints.

26 Jan.: I'm worried out of my wits about Nick. He has so much pressure on him and has had for so long a time. Carl is getting louder by the day. He has constant guests. Partly I'm jealous; I'm such an isolate. Also, it's hard to concentrate.

27 Jan.: The big canvas is now turning into a kind of homage to Matisse. It's still an embryo. I don't know where it will go. I must make my work—work. I could use a little luck.

28 Jan.: I called Williamsburg; they had not even sent my order. I called the Whitney. The Agnes Martin show will be there until Sunday. I plan to meet Nick at MoMA tonight.

29 Jan.: Went to Agnes Martin show at the Whitney. Nick and I had a wonderful dinner at Presto's. I rented two tapes—a life of Rembrandt and a Jean Renoir with Ingrid Bergman, *Elena and Her Men*.

31 Jan.: Nick left at 3 p.m. for Michigan. He will be back tomorrow evening late. I already feel separation anxiety. I plan to meet Jennifer for dinner.

1 Feb.: I'm to meet Jennifer to look for a wedding dress for her. Strangely, the big painting is beginning to go . . . a lot of things are coming together . . . maybe the strain of having Nick away released something from my unconscious. It's good. I feel in control.

2 Feb.: Nick returned. He's fine. I'm so relieved. Now Jennifer is in Atlanta. All these comings and goings. I worked well—nothing is finished. I feel a little dizzy.

3 Feb.: I went shopping for art supplies—first at 57th Street; I tried the League and Lee's. They were out of titanium white. I finally had to go down to Pearl Paint. This is all because Plansky didn't deliver. He's having a show and apparently Williamsburg has totally shut down. What a way to do business. If the paint from Plansky ever arrives, I'll take my time about paying. Let them call me—once, twice.

 I look around the studio—so much money has gone into this work that hasn't found any friends. I was thinking of the ass who at my last show spoke of my self-portraits as those of an aggressive woman. Aggressive woman! I paint therefore I exist. Doesn't anybody understand? I could use a little luck. I think some of my selves could hang with Beckmann and hold their own.

4 Feb.: Worked fairly well today—mostly on the big one. Color, color, color—always to be rediscovered.

7 Feb.: It's after five and I just arrived here. The studio seems cold—nothing is really moving—not even the big painting. A slow year.

8 Feb.: It has been a beautiful day. There is a touch of spring in the air and the painting is beginning to go. I feel some of the old juices—despite the fact that Karen called to tell me she is to receive a major review. I couldn't believe it. Her painting is "the nature of reality." I have to hold on to the old guys—Rembrandt, Velázquez, Goya, Cézanne. They all redefined

the nature of the thing seen; they created their own "real" with masterly conviction.

Carl just brought me a cappuccino—just when I needed it. This was so nice.

9 Feb.: Finally (late afternoon) paint arrived from Williamsburg. It's wonderful to have it. They were out of cadmium red—their most beautiful color.

10 Feb.: It's a beautiful day—bright and sunny. I've just spent an hour re-arranging the studio. I'm incredibly lucky to have this studio and yet it is not big enough. I wanted to take *Excavation* out and look at it. I'm having trouble "finishing" anything.

11 Feb.: I feel very isolated. The phone hardly ever rings. I love the studio but I certainly could use some *encouragement*. I'm thinking of starting a still life but I don't know where to set things up. It would be nice to have something that could sell.

12 Feb.: I read the review of Karen's show. I'm speechless. I can hardly believe it. How can anyone take such work seriously. Who is out there for me?

14 Feb.: Nick and I went to the Fair; he bought me *three* wonderful art books: one a study of twentieth-century watercolors; one by Sam Hunter, *Modern Art*—a survey; I always need such books (an overview)—and the book on Seurat's drawings that I coveted last week. Later I worked on the big canvas. Nick came and suggested a lemon yellow—at the top. The whole thing fell apart. I struggled; my favorite green glass vase broke . . . it was a day of joy and pain. I think the canvas survives (so do I).

16 Feb.: Not much work. I'm still "looking" at the big canvas.

17 Feb.: Today "MOODS": I was high in the morning, low in the afternoon. I've only done two studies—both of the rose that Stephen brought me on Sunday.

19 Feb.: I went through my slides this morning to get a group together to send, via Liza, to the Newark show. It's discouraging to see how little I've accomplished with so much money spent—so much time.

20 Feb.: I was low most of the day but I perked up toward the evening and started reworking one of the *Three Maris*. It must weight 300 pounds.

21 Feb.: Nick and I went to the Fair—in the snow. I'm still reworking *Three Maris*. What is the fate of that ambitious canvas?

22 Feb.: I'm reworking the other *Three Maris*.

23 Feb.: I'm still working on *Three Maris*—one and two.

24 Feb.: I was just reading Richard Brilliant's book on portraiture. It's really a study on the nature of identity. He seems to take the post-modern position.

25 Feb.: I took the diptych off the easel; it's not quite finished. I think it's my best painting.

27 Feb.: I went to SoHo to see Sharon Duffy's show and take my slides to Lucy Barber—to be juried for the show at the Newark Museum. I wonder if they will take anything of mine. I visited some SoHo shows. I saw nothing that really stays with me—but it was good to look at paintings.

28 Feb.: I reworked the two smaller versions of *In the Studio*. The building is falling apart. There is no light in the hall and the sink is stuffed.

1 March: So far a slow day. I need a new canvas and I'd mine the storeroom if there was a light in the hall. I can't quite make up my mind whether to paint over *Two Skulls*.

2 March: It's been a good day. There's a hint of spring in the air. I struck a new canvas (on Stephen's stretcher). I came in and worked with intensity—almost from the moment I got here. The painting may be too Beckmann-esque. I could fall into that and I must watch it.

5 March: Carl's "Open Studio" takes place tomorrow. It's going to be hell in the studio for three days. I can't help resenting Carl. He doesn't see me at all. His wife too is utterly vain. I *must* get on with my work! I have no interest in Carl's work. It's beautifully crafted but to me is vacuous . . . one moment he makes a Roman mosaic—the next a Chinese painting. Why?

6 March: Carl's party is in full swing and it's almost impossible to concentrate. I worked on the painting I struck the other day. Considering the hellabaloo it went very well.

8 March: I arrived late at the studio. Carl—the happy, self-satisfied artist—told me about all the people who had come by on Sunday to see his show. Wendy Gittler came by (she called first) with a friend of hers from Connecticut; Wendy seemed to like the work but I wouldn't bet on it. She does not have a faithful or an original eye. Still, Wendy will come, and she looks. Nobody else is doing that for me—lately. I lent Wendy my John Walker catalog. She did not know J. W.'s work.

9 March: We leave tomorrow for California for five days; I spent most of the morning packing. I miss the studio *so* when I'm away, and last week Carl stole so much time from me. His open studio—he says—was a huge success.

16 March: It's good to be back at the studio! Yesterday (back but very tired) I reworked the *Three Maris*—again. It's better but I'm still not sure of it.

18 March: Last night I heard Stanley Lewis speak at the Studio School. I think he is a painter of some interest and yet—last night—he played it for laughs. I feel so out of everything. Is any of my painting any good?

19 March: I'm not doing enough work. I need to sink into it—to find new ways. Maybe I'll have a good summer. Every day is a gift and yet I can't always use it. There are some good shows in town. *Picasso and the Age of Iron* is at the Guggenheim. Tonight I'm off to see the Greek sculpture show at the Metropolitan. Why is there so little time?

20 March: The Greek sculpture—at the Met—was wonderful—especially *Nike Adjusting Her Sandal* from the Parthenon. It's a marvel of weights and balances. I'm still not really into much work. . . .

22 March: I went shopping and bought a dress for Jennifer's wedding—also a jacket. I came back to the studio and tried them on. Costumes.

23 March: I went shopping for a blouse; on my way home I stopped at Salander-O'Reilly . . . there's a marvelous small show of Blakelock.

26 March: Tomorrow is Jennifer's wedding. I don't know why I'm so nervous. . . . My painting is at a virtual standstill until after the wedding.

From Delacroix's journal: "Man is a social animal who detests his fellows."

1 April: The wedding is now a memory. It was a great event and went smoothly—except that, in the confusion of clearing out of the restaurant, Ted Weiss's gift to Jennifer and Steve was lost—a print by Matt Phillips. I can't seem to reconstruct this week. I've been coming in to work but not much has been accomplished. Yesterday I went in the morning to see the Havemeyer Collection at the Met. It's great. I must go there again and again. Jennifer and Steve are due back from Boston today. I must place an order from Williamsburg. I need some cadmiums. Also I need palette paper, painting gloves, Silicoil.

2 April: I arrived at the studio late; I've had a hard time concentrating. I think those images from the Tarot will be my new motif.

3 April: I went to the Francis Bacon show at Marlborough. He really knew how to use space. I went to see shows by Nell Blaine and Wolf Kahn. Both shows were nearly sold out. In the evening Nick and I went to see the Havemeyer Collection.

4 April: I really need a masterpiece—something to get me going. I'm trying to get the courage to paint over the skull painting.

5 April: An awful morning. The dryer smoked, leaving the whole house smelling of fire. I almost got run over on the way to the studio. The cash machine at the bank failed to return my card. Still, I am determined to start a painting.

6 April: I struck a painting over the skull painting. So far there is nothing there except for some nice quality in the paint.

7 April: Happily there is some light today. The strike—from yesterday—does not look too bad. An order from Williamsburg arrived today.

8 April: It's a beautiful day but I feel somewhat out of sorts. Last night we viewed a videotape of the wedding. I was appalled by my image in photos and video. While we sat at dinner I became dizzy. The whole room swerved. I must get on with my work.

9 April (Good Friday): I went to MoMA last night with Nick. It really got me going. I looked at Picasso's *The Three Musicians*. The new painting is really coming on—almost too fast. It contains elements of a Last Supper (fitting for Easter), *The Three Musicians*, the Tarots, Goya, and yet it's new. I think it will work. I cashed my check for some *Spring Creek*s. Money for work—lovely.

13 April: I worked on *The Last Supper*. It fell apart. I'm most worried about the surface—everything else can be saved.

16 April: I'm going to a meeting at First Street—also to SoHo to see some shows. *The Last Supper* is still drying.

17 April: Margot's opening was uncomfortable for me. I have the feeling she dislikes me. Sad. Her work is technically accomplished but arid. Saw the de Kooning show.

18 April: I worked a little this afternoon. I'm still after meaning (from the unconscious) and painterliness.

19 April: Worked some in the afternoon. I think *The Last Supper* is coming along.

20 April: Is *The Last Supper* any good?

24 April: Last night we went to the Met. We looked at Ming painting of the 14th and 15th century. I arrived earlier than Nick and spent an hour at the Havemeyer Collection.

25 April: A beautiful day. We stayed late at home and then visited the flea market. I bought two sunflowers for a still life. Tonight we will have dinner (at the Oyster Bar) with

David Douglas Duncan. I can't wait to hear him speak about Picasso! This week I must

1. start still life from observation
2. cull another large canvas from the storeroom for another version of last supper
3. start at least one small version of *Last Supper*.

26 April: I struck a still life with the two sunflowers (very fair). We had dinner last night with DD Duncan and his wife Sheila at the Oyster Bar. It was an extraordinary evening. Duncan seems to want to elevate Picasso to sainthood—to contradict Mrs. Huffington.

29 April: Still have not finished the large *Last Supper*. I think it has to sit for a day or two. I turned the small version against the wall. I must work harder; it has been a slow year.

30 April: I think the *Last Supper* is almost done!

1 May: I spent the afternoon going to galleries. I started with Jack Beal. I liked the earlier work better; in the later (more realistic) work everything is monotonous. He paints *frozen* gladiolas. Then to Marlborough to see Magdalena Abakanowicz. I like her work (mostly the burlap figures in this show); the drawings of heads I liked least. Then to Robert Miller to see the penultimate abstractions of Joan Mitchell. In some of these it was the will to paint to keep alive that spoke. Some were too slapdash. I walked up Madison Avenue—it was a beautiful day—to the Frick. I looked at the Frick Rembrandt self-portrait. Is my evoking it a sacrilege? The Frick is wonderful—the clarity, the certainty of the old masters! Last I went to Gagosian to see the Giacomettis. It's a stunning show.

2 May: I arrived at the studio about 2 p.m. I took the *Last Supper* off the easel. It needs to sit for a while.

3 May: I'd like to finish the skull and sunflowers painting today. I'd like to start another large painting this week. Time is passing.

4 May: I got in late. I had a hard day yesterday and almost ruined the painting I had

been working on—off and on—since last fall. Pushing things around I broke the glass on a frame. I was in a cold sweat.

5 May: Time. Can I live long enough to do the kind of painting I was meant to do? I have a pain in my lower back. Will it pass? I'd like to start another large painting. I must do something about getting supplies for me to work in the West.

6 May: Suddenly it's almost summer. Will we get to Ennis? Will the supplies arrive in time? I called in an order for art supplies from Williamsburg:

5 cans titanium white (16 oz.)	1 can phthalo turquoise
1 can cadmium yellow lemon (8 oz.)	1 mars yellow deep
1 can cadmium orange	1 mars violet
1 can cadmium red medium	One gal. rectified turp.
1 can Alizarin crimson	Greens—buy in Old Holland
1 can phthalo blue	Watercolors
1 can phthalo green	Palette knife
1 burnt sienna	Silicoil
1 raw umber	Goop—drugstore

8 May: We went to the Museum of Natural History with Nick's author who loves archery. We looked at bows and arrows!

11 May: On my way home from the dentist I saw three exhibitions: Brice Marden at the Marks Gallery, Elizabeth Butterworth at Graham Modern, and Constable prints at Salander-O'Reilly.

12 May: I culled a large canvas from the storeroom. I'm eager to strike another *Last Supper* before we leave.

13 May: Went to the hardware store to get screw eyes to prepare a canvas for the group show *Flesh* at First Street. I called Marvin at Tri-Mar. He estimated that it would cost $77

a canvas (with double-primed canvas) to send these to Montana. I ordered five. The crate will cost $75.

14 May: I went to the Library Fair. Jed Perl was there and he called me by name. "I always see you here," he said.

15 May: Nick and I took a walk to the AT&T store uptown. We had lunch at The Dock; it was a lovely day.

19 May: I'm off to the Awards Ceremony at the American Academy with Jennifer.

20 May: Painted all afternoon on *Last Supper II*.

21 May: Sat First Street all day: dull. We had a nice family dinner at Patzo's. Anthony has just graduated law school.

25 May: I saw the de Koonings at C. M., Joel Shapiro at Pace, and a marvelous show at Jason McCoy called *Expressive Heads*. At IBM I saw selections from the Irish National Museum—a wonderful Velázquez, a Titian, a maybe Goya, the Mantegna—and much also that was mediocre or bad; also, I looked at the companion show, O'Keeffe and Stieglitz. The photographs are surely of more interest than her paintings (mostly insipid).

26 May: I worked on *Last Supper II*. Nick invited Peter Selz over for dinner with his ex-wife Thalia (and Gaby, who was in Paul's class), and David Geiser. He probably won't like my work. I feel invisible.

27 May: I took some self-portraits out of the racks to look at them. My self-portraits remain my favorite work—no matter what that jerk at Frumkin said.

28 May: I'm expecting Anthony to come over and bring some canvases back to the house—for Peter Selz to see (he probably won't look); he may not even come. Anyhow, it looks like rain. Nature may be against this enterprise.

29 May: Peter Selz is expected for dinner tonight. I wish this evening was over; he

probably won't even look at my paintings. Courage—tomorrow I must work.

30 May: The Selz dinner is behind us. Peter Selz *did* look at my paintings (a little); he liked the blue still life and the watercolors. It was a nice evening—some art talk. Superficially it was pleasant. I sensed some despair in Thalia Selz. Why were we all having dinner together? Strange. But I did enjoy it. I worked today on the smaller *Last Supper*. I feel my mortality; my back is hurting.

31 May (Memorial Day): We had a wonderful lunch—on "Restaurant Row"—at Joe Allen's (memories of London). I got to the studio late—mostly I thought and looked, at paintings, at books.

1 June: I started to order things from Utrecht. I must go into high gear about getting supplies to Montana. Will I ever paint?

Utrecht will send six canvases and a new French easel to Montana.

I celebrate the things of the studio—the palette as something expectant, alive, a shield that protects as it floats over the image. The studio horse is a metaphor for youth and energy. The carousel goes around and around like infinity. When it stops we get off.

September 1995: For several years I had been doing a series of self-portraits; they were intense, or was I doing battle with my ideas of art, of self-hood? How could I, a middle-aged woman with no fame, be part of an art world that doesn't know I exist (I paint, therefore I am?). I painted myself with my mirror image in a series called *Portraits with Adumbration*. I painted myself humorously with my "friends," Rembrandt, Beckmann, Velázquez, Cézanne. They were the spirits—alive in my consciousness—who inhabit my studio. I am fairly alone in my work. I am envious of the artists' clubs and groups that became a support for painters in the 1950s—and that may exist now, perhaps informally, for some. I have very few artist friends and those I do have are concerned, naturally, with their own work; they can rarely be persuaded to make a studio visit. I'm lucky to have a wonderful husband who is my source of support—financially and spiritually.

More Notes to Herself

FOR SEVERAL YEARS NICK and I have visited Ennis, Montana in the summer—Nick to fish and write, and I've always taken watercolors with me. Mostly, I put these sketches in portfolios—when we returned to the city. I like to think that my investigations in front of nature informed my work in the studio.

The summer of 1993 was different. We did not stay with friends; we rented our own cottage, "The Downing House," overlooking the Madison River—and I had fifteen 18" x 24" canvases shipped to Montana. The landscape was breathtaking . . . but the weather did not cooperate. In five weeks we had scarcely an afternoon when the wind did not come up, mistral-like, and carry my canvas off with it. It rained, it was cold, it snowed. I resorted to working mostly on the back porch, mostly indoors looking out.

When we returned to NY in August the heat was oppressive. I have never installed air-conditioning in the studio. Though I've been here sixteen years, I feel temporary.

I began to paint larger versions of the oil and watercolor studies. Within a few weeks, by early September, my studio became a surrogate Montana. The cool colors and the

mari lyons

memory of the cool weather made the heat bearable. I made my own Montana. One canvas brought forth another and the process is still going on.

•　•　•

My Montana landscapes celebrate nature as an extension of self; one finds *in* nature, in Montana, nature is marvelous (the Surrealists spoke of the phantasmagoric aspect of reality) and in flux, always changing. In the vast spaces of the American West, still unknown, spirit, mystery, and many states of MIND. The subjects of these paintings evoke Jungian archetypes while being specific. There are paintings of a particular pond, a spring creek famous to trout fishermen for its wild brown trout, cottonwood trees, a hayfield, two fishermen in active pursuit of a trout, a young girl on a porch looking across a river at Sphinx Mountain. Such motifs unite the subjective and the objective.

•　•　•

I wanted to see the Montana landscapes with a naïve eye, as did the first painters of the American West, as though it had never been seen before; but I carry, in the baggage of my mind, images of landscape seen through the eyes of the painters I love—Cézanne, Courbet, Turner, Kandinsky, Pollock, Marin, and the vast vistas in Titian.

•　•　•

Any motif—still life, landscape, figure painting, portrait—can be a reflection of self, a ghostly projection of one's self—seen face to face. I have found this in mountains, streams, clouds, a pond, a hayfield. Every place has its particular genius.

•　•　•

There is an excitement in nature: the way the light changes, how water and clouds move and are transformed. John Dewey urged the artist to seek "stability and order in the whirling flux of change," what Wallace Stevens calls a "rage for order." I try to carry the energy, the flux into the painting.

•　•　•

I try to translate the observed into the aliveness of painting.

PAINTINGS

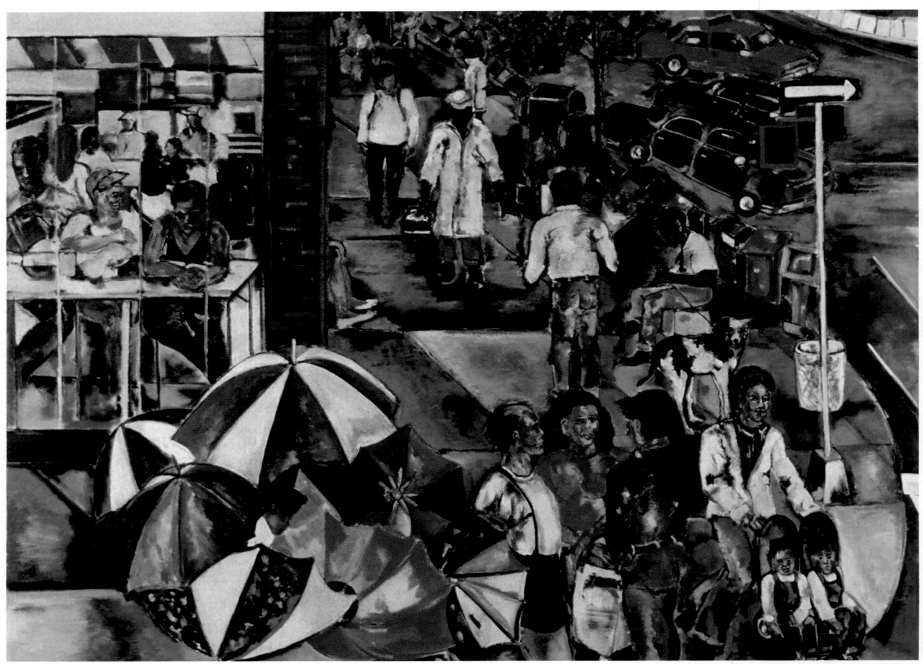

"Thursday Afternoon on the Corner of West 80th Street and Broadway" 2001 O/C 48"x72" *New York State Museum*

My Cityscapes

AS I LOOK OUT the window of my New York studio at Eightieth Street and Broadway, I see a thousand possible motifs: if I look to the left or the right, uptown or downtown, Broadway changes. The seasons pass and bring with them variations of color and shape in the trees on the traffic islands in the center of the street; shops alter more frequently than one would suppose; and the daily traffic of people and vehicles is new moment by moment. The street can be hectic, erratic, sometimes even serene. What I see is the life of one corner of a great city—its throbbing rhythms, its mutability. In some ways it is an impossible subject—my city. I love it.

Although I constantly look out my window, and need the direct experience of the motif in front of me as I lay in the initial composition in charcoal, and for a good part of the time I paint on the painting—I am not a purely perceptual painter. Even if it were possible to paint a New York street as it is any given moment, it would not be true for me. I am, of course, engaged in the problems of describing what I see . . . for instance, I used to wonder how I could represent cars as they sped along. I did not want to paint—even if I could—a Ford or a Volvo; I wanted to give the forms the energy of a car, a truck, a

bus, in motion, seen from my third-floor window. I now represent the cars as they pass as a little of this car that passes, and part of another. As for the pedestrians on the street—I draw an arm here, a leg there—as they walk quickly by. Very rarely, I get a whole figure all at once, as I see it, and when I do I am very pleased! Sometimes my figures, such as the ones in *Thursday Afternoon*, could not fit into my cars. So much the worse for them! They fit onto the canvas in a way that is real for me. I conceive of the city as something like a Cubist construction, with the angles of buildings, the street signs and the markings on the street, and of course the people, veering off in all directions.

The textured "thingness" of what I see leads me to build my own world—in places fractured, elsewhere palpable and solid or even somewhat naturalistic-looking. I reinvent and re-work what I observe in order to find on the canvas a world that, like this New York scene, is filled with energy and flux. In many ways I see my street as one metaphor for my life as a painter in these tumultuous and fractured times.

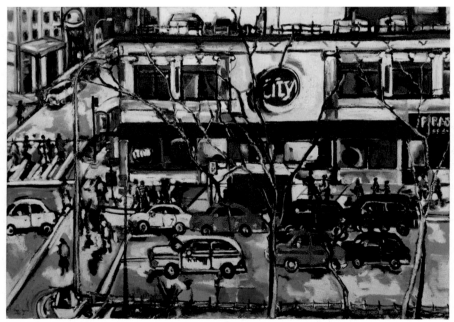

"Broadway with Circuit City in Winter" 2003 O/C 48"x72"

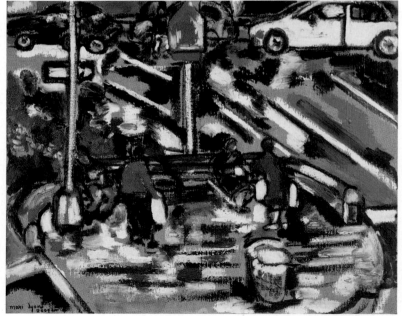

"People on Island Bench" 2009 O/C 16"x20"

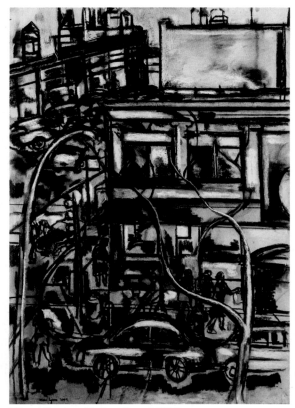

"Street Scene with Bent Trees" 2009
Charcoal on Paper 39"x27"

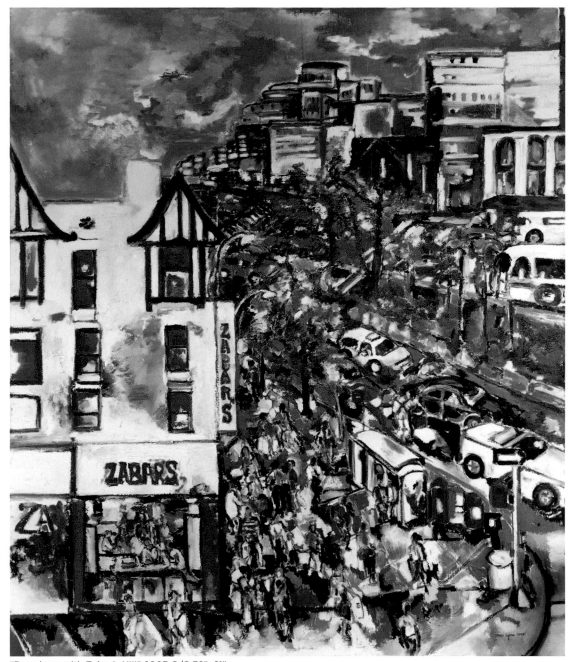

"Broadway with Zabar's XIII" 2003 O/C 76"x61"

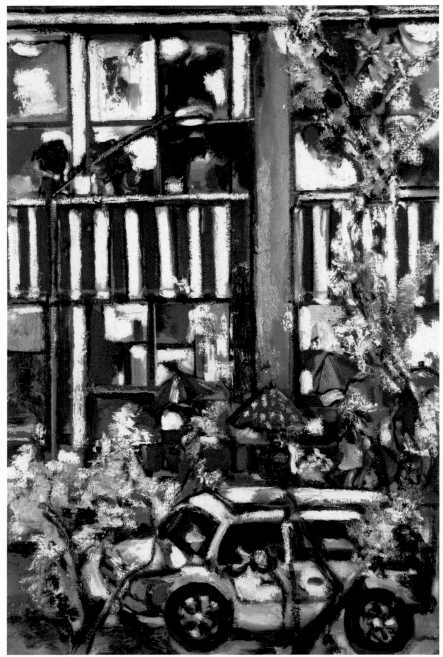

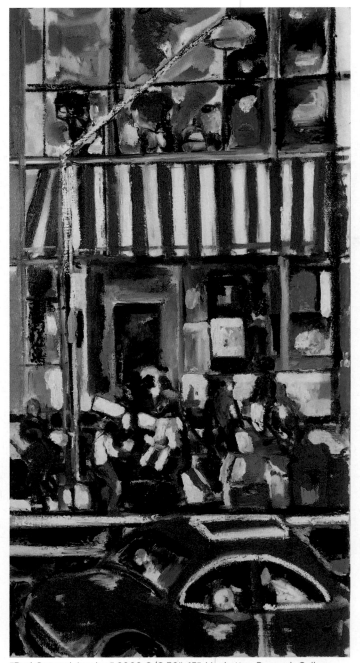

"Snowy Trees with White Car" 2010 O/C 36"x24"

"Red Car and Awning" 2009 O/C 30"x15" *Manhattan Borough College*

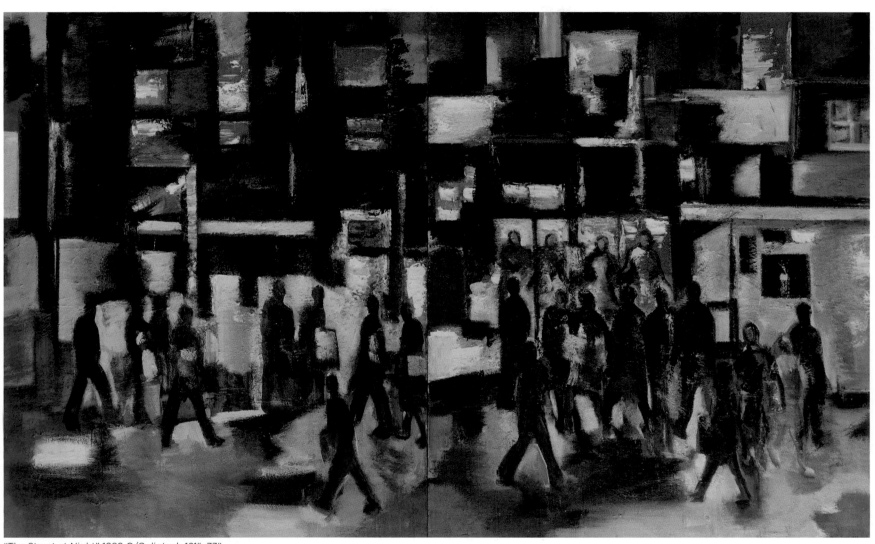

"The Street at Night" 1988 O/C diptych 121"x73"

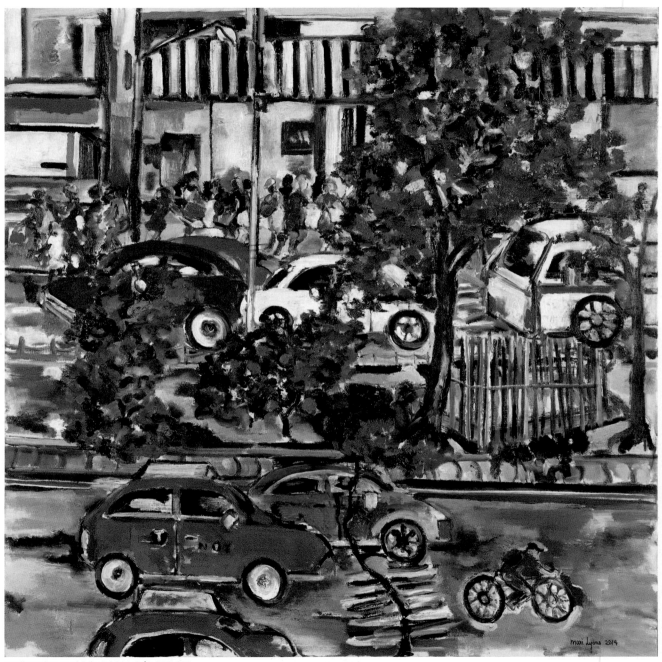

"Yellow Car and Bike" 2014 O/C 37"x37"

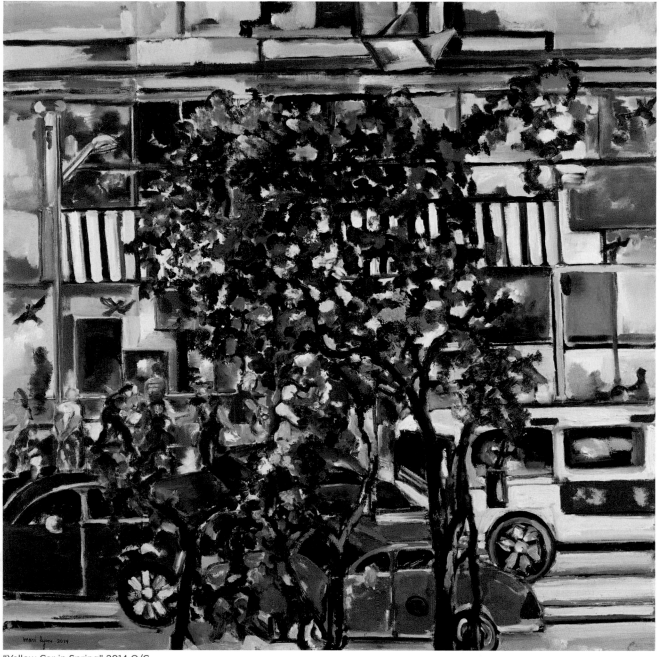

"Yellow Car in Spring" 2014 O/C

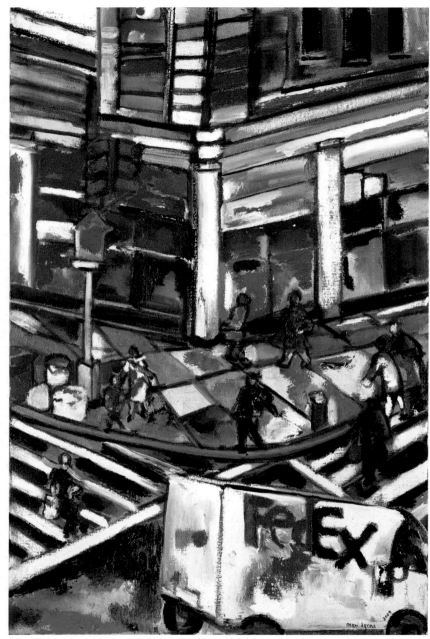

"The FedEx Truck III" 2009 O/C 36"x24" *Rudolf Steiner School*

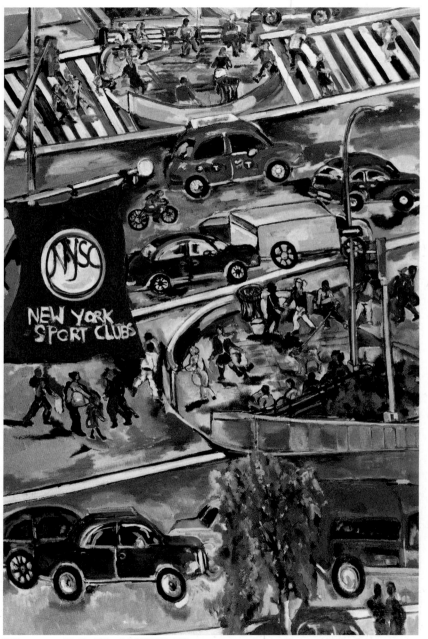

"Cityscape with Red Flag" 2012 78"x55"

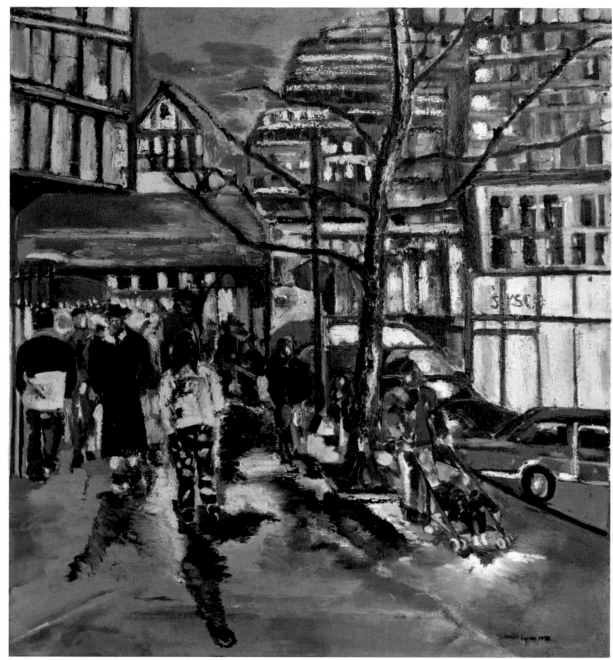

"Walkers Under Awning 1982 O/C 44"x41"

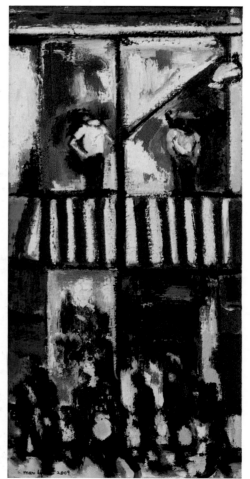

"Sidewalk with Striped Awning"
2009 O/C 24"x12"

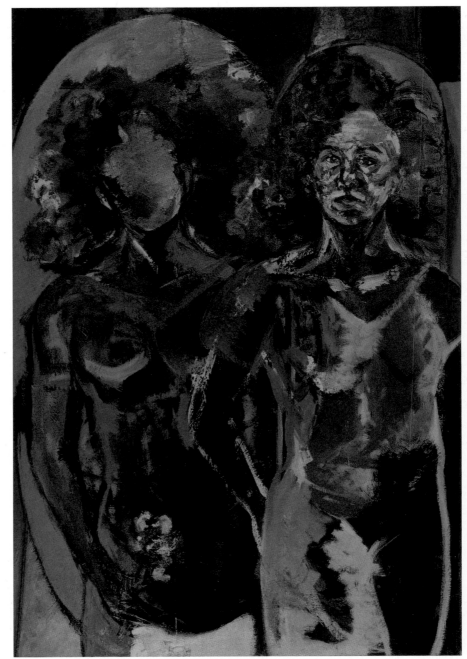

"Self Portrait with Adumbration" 1991 O/C 84"x60"

Figures

I HAVE DRAWN AND painted the figure regularly for more than sixty years. Often I worked from a model, either alone or with two or three colleagues. We would start with two- or three-minute sketches, then go to ten-minute poses, and finally long enough sessions for more serious work, mostly in pastel on paper. For the past fifteen years I mostly worked alone, and in oil. I used Fabriano paper for the most studied drawings from the model, on 27½" x 39½" sheets. I have painted a large number of self-portraits, probably because the model's cheap and always available.

One series was the double self-portrait. I worked with a mirror for these and called them *Self-Portrait with Adumbration*. Looking in the mirror, I was both the painter and the model.

Over many years I have filled nearly one hundred sketchbooks and made thousands of loose figure studies, mostly in charcoal and pastel, but more often lately in oil. Like Cézanne and Hélion and many others, I have always believed that drawing was the heart of painting; for me this has been especially true for the human figure—from a model, a self-portrait, or in the landscape.

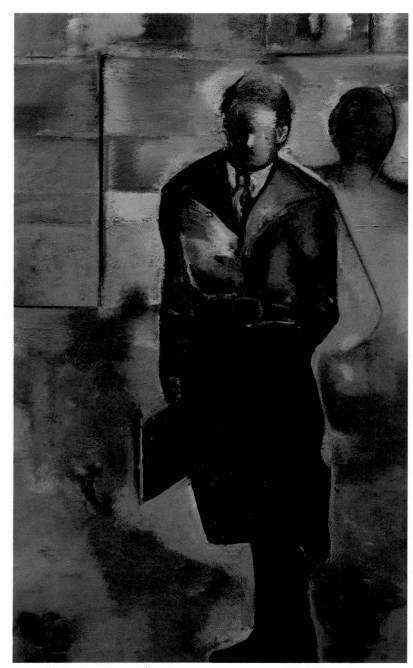

"Man with Briefcase" 1987 O/C 78"x48"

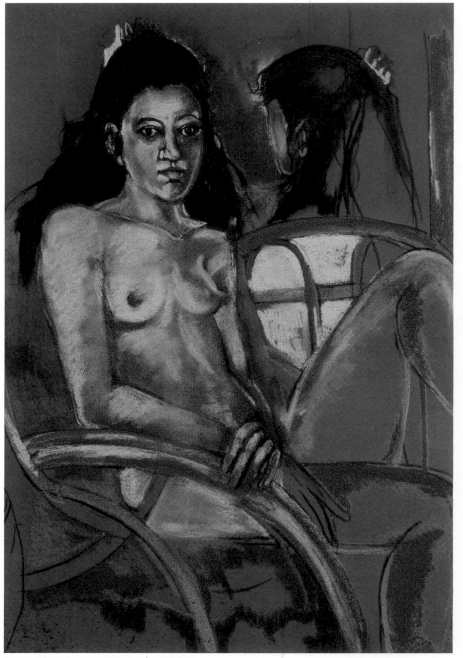

"Noa with Reflection" 2000 O/C 39"x27"

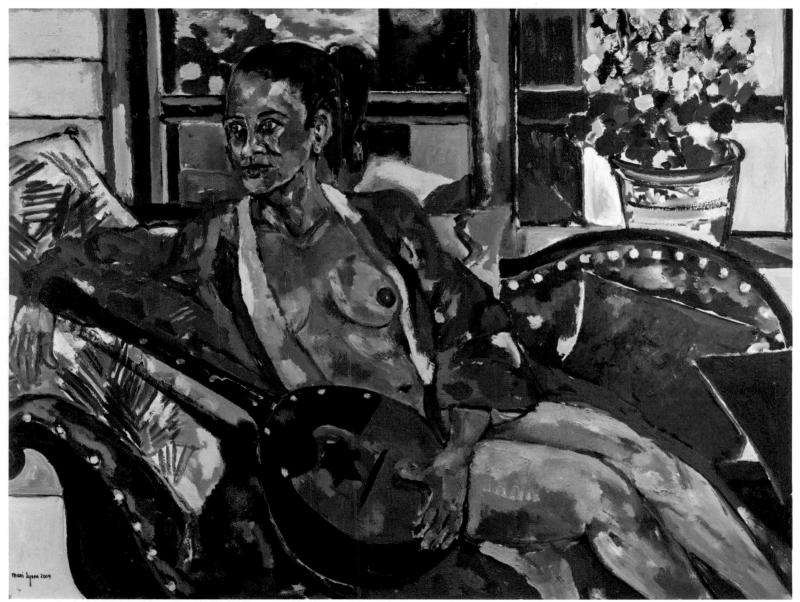

"Model on Lounge" 2004 O/C 37"x48"

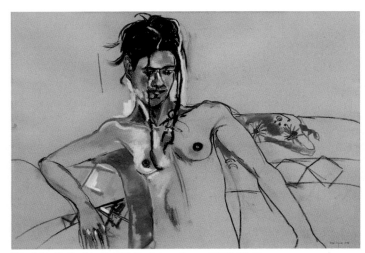

"Model with Braids I" 1998 Pastel on Paper 27.5"x39.5"

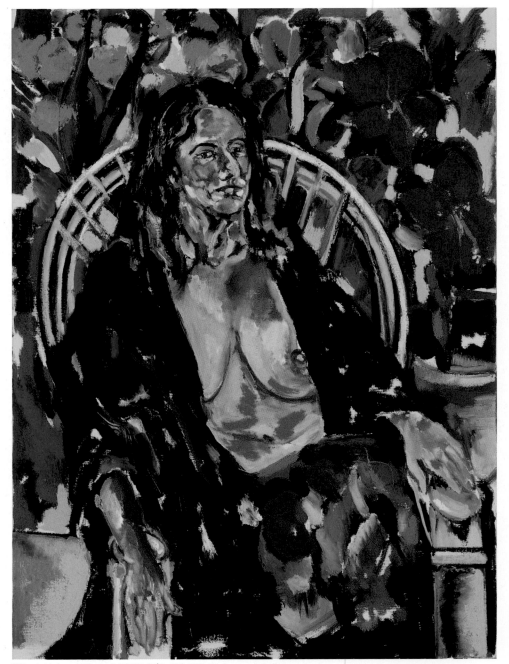

"Black Hair and Robe" 2005 O/C 48"x36" *Richmond College*

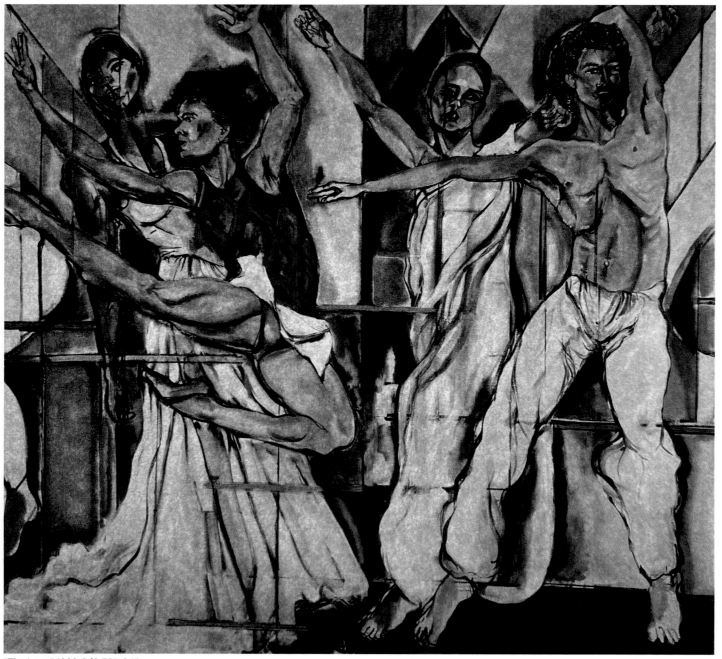

"The Leap" 1982 O/C 78"x84"

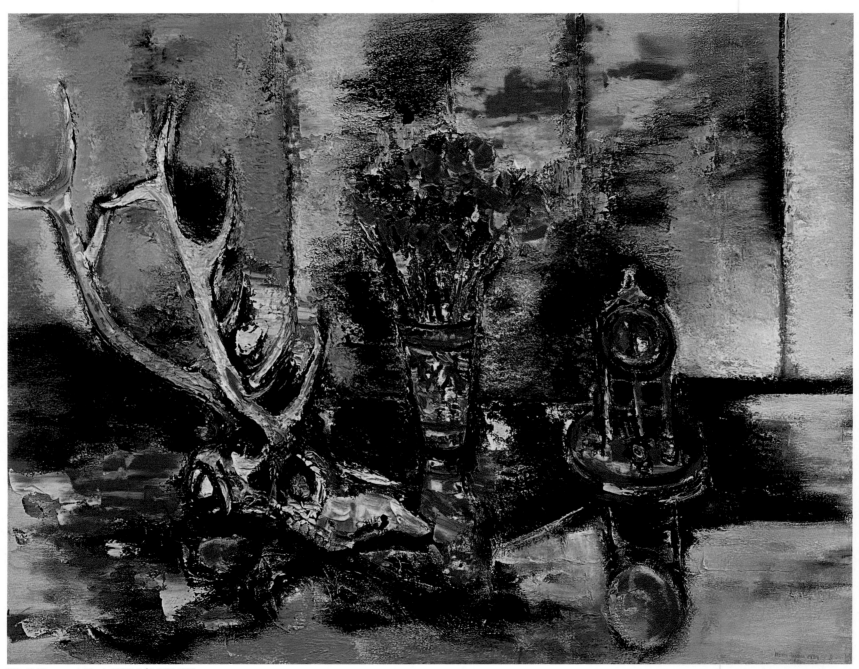

"Skull, Vase and Clock 1993 O/C 60"x78"

Skulls / Classical Presences

RICHARD EBERHART, in his poem "The Groundhog," evokes a muted terror as he watches the animal's dead body decay. When the decay has done its worst, there are only bones, "beautiful as architecture." Only these remain, the residue of a life.

I hope my skull paintings contain the quiet and natural gravitas of death but mostly the exquisite harmonies of an elemental form filled with shadow and substance. I was born in the West and I have spent seven or eight summers there, and I have always been fascinated with the bones bleached in the hot sun of Wyoming and Montana, purged of the vitality and impurity of life yet still charged with both and now fit objects for an artist's contemplation. I began to paint skulls when my father, a cattle rancher, brought them home.

Some critics have compared my skull paintings to those of Georgia O'Keeffe but they are vastly different. Mine are visceral, animated, painterly. Mine are never icons, though when I have painted them with a clock, armatures, flowers, or me, they surely suggest a vanitas. They are themselves. Their texture and presence need no more—no message. They have never seemed morbid to me. They are in some ways no more skulls than Cézanne's apples are apples.

"Greenish Skull" 1976 Oil on Paper 18"x24"
Northeastern Nevada Museum

"Horned Skull IV" 1984 Oil on Paper 22.25"x25.5"
Northeastern Nevada Museum

I acquired two Greek statues from the Maurice Glickman estate and they became regular presences in my New York City studio. They remind me always of the classical commitment to harmony and beauty and they became important images for me. They were neither still lifes nor figures from life but they were alive and watching me as I watched them—and I listened to what they have to teach.

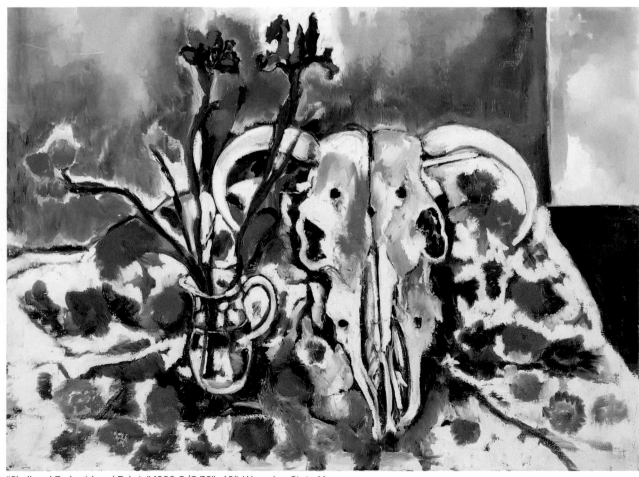

"Skull and Embroidered Fabric" 1986 O/C 36"x40" *Wyoming State Museum*

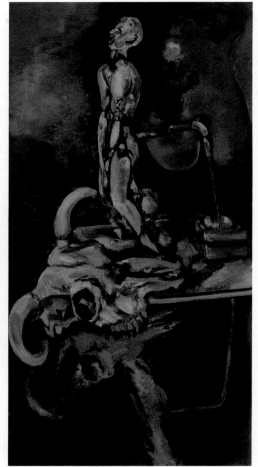

"Skull, Acrobat, and Palette" 1985 O/C 75.5"x39.75" *Arizona-Sonora Desert Museum*

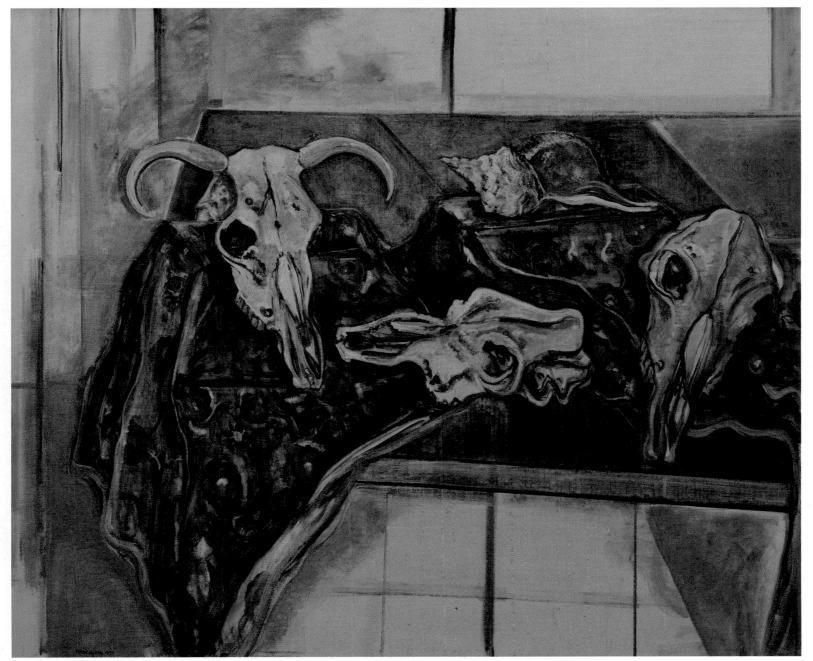

"Skulls on Green Cloth" 1979 O/C 59.5"x79.75" *Arizona-Sonora Desert Museum*

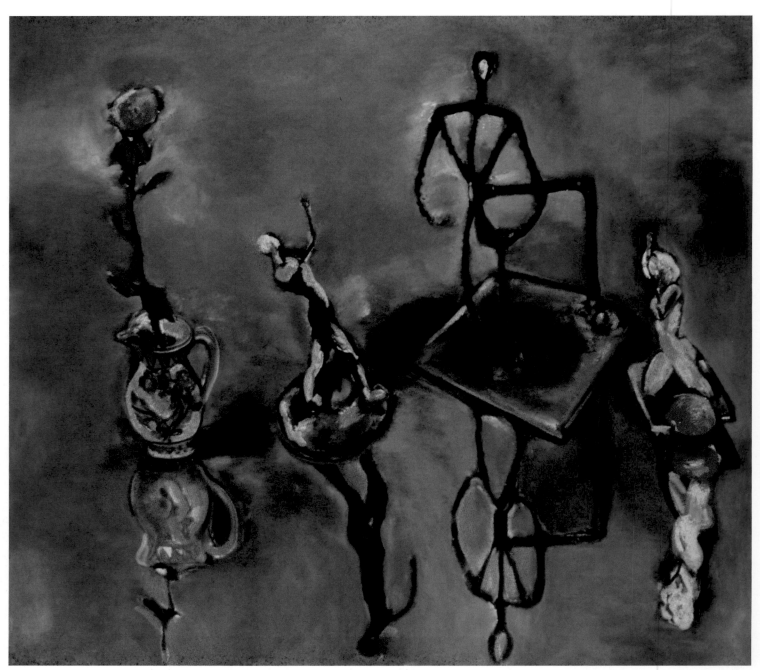

"The Life of Forms in Art" 1984 O/C 69"x78"

Still Lifes

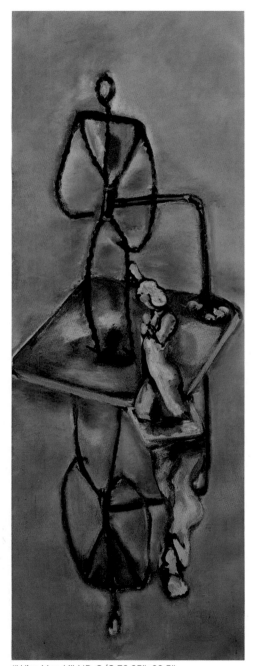

I HAVE PAINTED *nature morte* regularly since I was a student. It has never exhausted its possibilities for me, any more than it did for so many masters whose work is in this genre—Cézanne, Mucha, Velázquez, Goya, Zurbarán, Rembrandt, Manet, Matisse, and a great host of others, painters whose work I love. Over the years I have constantly searched for the fullest possible use of the genre. For patches of time, the places in which I have painted have affected the still lifes I painted—a bedroom, a rented room on West Eighty-Fourth Street, a studio overlooking Broadway, a country studio with skylights, slatted boards for walls, and crowded spaces—and the furnishings, the carousel horse I bought in Saugerties, an arched Asian mirror, a *guéridon*, a Persian pot, items bought in shops or flea markets. Often I used traditional still-life objects—some pears, a bowl of fruit, a glass, a bouquet—but also highly suggestive objects such as animal skulls, plaster casts of classical Greek sculpture, a wire man maquette, tubes of paint, and other accoutrements of art. A watercolor painted in Hawaii, on a trip to visit our eldest son, found its way into one still life, a guitar into another. In their variety, colors, tension, drama, and counterpoint, these still lifes affirm for me that the genre is ever rich in possibility and a vital kind of painting capable of being as much of our time, as significant as any other genre.

"Wire Man V" ND O/C 78.25"x28.5"
Arizona-Sonora Desert Museum

Mostly my still lifes are an expansion of my painterly vocabulary, which is always in flux. Some are more singular and smaller than my pulsating cityscapes but always a constant form of renewal for me and "relevant" to my more ambitious work and more intimate. In them I push myself to try fresh pictorial directions, to explore many of the problems I set for myself, both structural and otherwise. Sparseness or efflorescence? My still lifes are not academic. They come out of the abstract painting I once did and are leading—in their constructs and shapes, forms, line—to a new abstraction, a constantly evolving view of what can be done with paint on canvas, that a few pears or a simple group of "August" lilies can be fleeting, ephemeral, mysterious, and perhaps even an antidote to post-modern coolness or commentary.

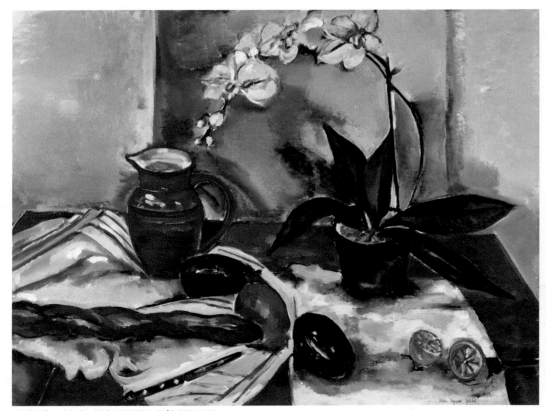

"Still Life with Orchid VII" 1984 O/C 69"x84"

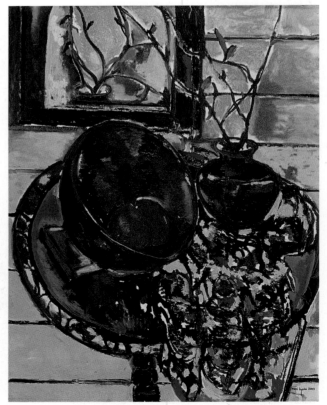

"Oranges in a Bowl" 2003 O/C 45"x36"

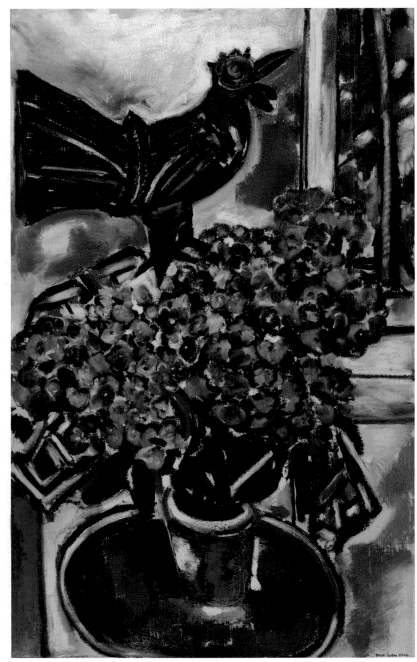

"Still Life with African Bird" 2006 O/C 48"x30"

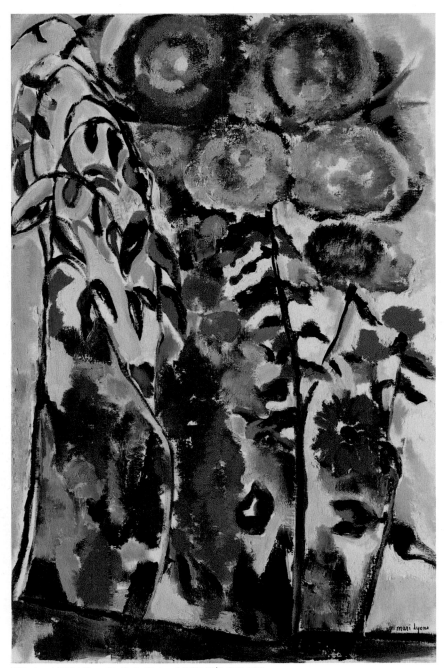

"Abstract Still Life with Pink Globes" 2011 O/C 37"x25"

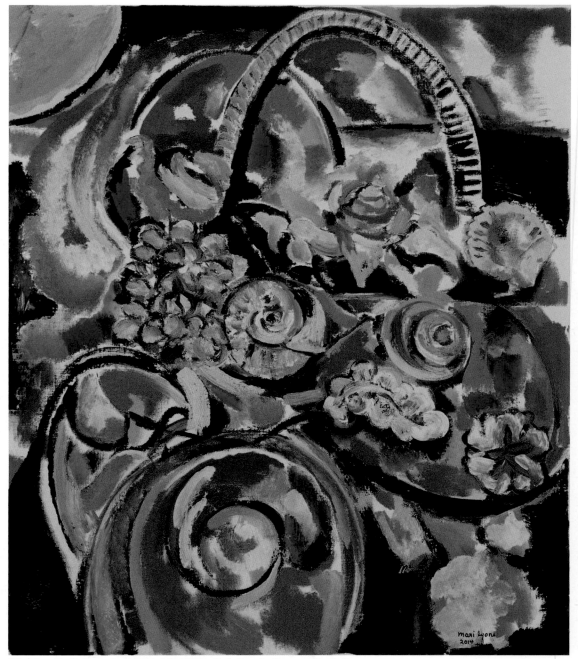

"Floating Shells in Basket" 2014 O/C 30" *Suffolk County Community College*

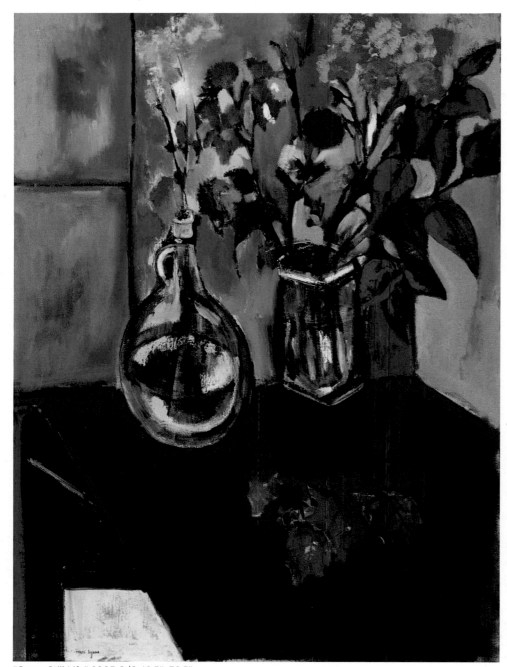

"Green Still Life" 2005 O/C 48.5"x36.5"

"Two Tubes of Paint III" 1981 O/C 13"17"

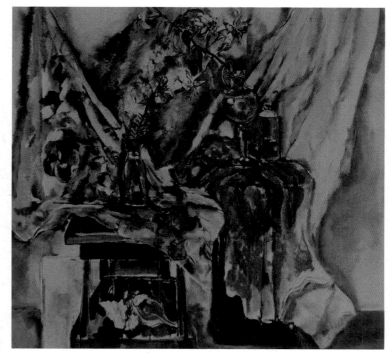

"Flower Still Life XX" 1980 O/C 78"x84"

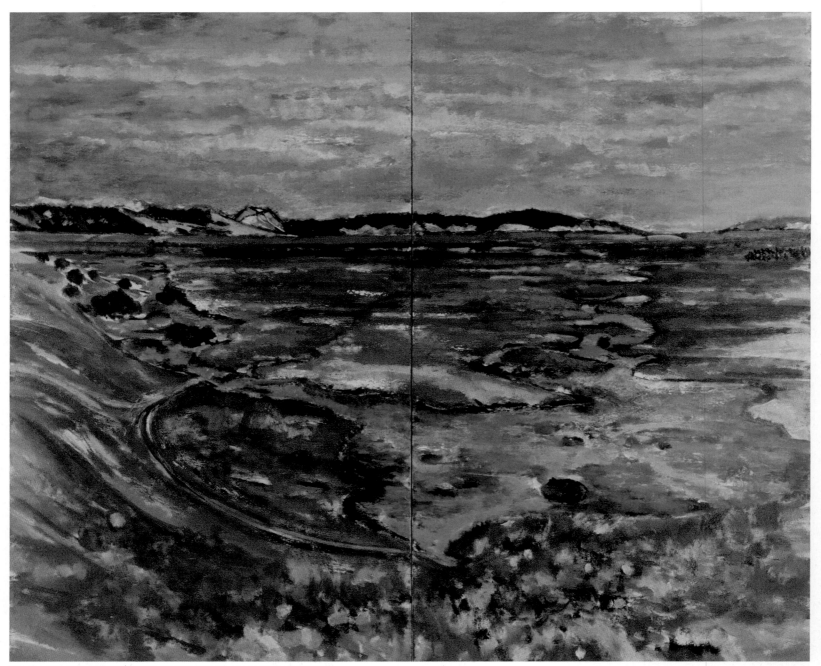

"Spring Creek X" 1995 O/C Diptych 86"x98" *Montana State University*

Montana Landscapes

MY MANY MONTANA LANDSCAPES have given me a unique opportunity to explore outdoor space—much of it vast and inspiring but sometimes local and intimate. I have tried to capture the special poetry of this place—its bright rivers, haunting mountains (like the Sphinx, in the Madison Valley, which I painted several dozen times), and seeming unending space. At first I was intimidated by the space. I had painted New England landscapes when I was at Yale-Norfolk, and randomly in other parts of the East, but the landscapes of the West are different; the challenge was to bring their life into the life of the canvas, without being decorative or illustrative. I tried to bring the vitality of Beckmann into these canvases—and a simple exuberance in their personal structure; and I wanted to paint figures in the landscape.

I did small pen-and-ink sketches, and small watercolors. I also painted dozens of smaller works of the fields and mountains and, more intimately, a pond behind the Stone House, and the old Power House, in which we lived. I worked from sketches and memory when I returned to my studio in Manhattan. Many of those made in the city are quite large, more studied, and not nearly as loyal to what I saw as to what the forms on the canvas demanded. A diptych made in New York City now graces a wall in the Special Library of Montana

State University, and other "Montanas" are owned by the Montana Museum of Art and the Montana Historical Society. Many of the drawings and even the large paintings include fishermen, which gave me a great opportunity to paint figures in the landscape. I was pleased to see work from my sketchbooks used in books on angling by my husband, Nick Lyons, and paintings used on his jackets.

Visits to Montana helped me explore a world different from that in my studio and to enrich my painting vocabulary.

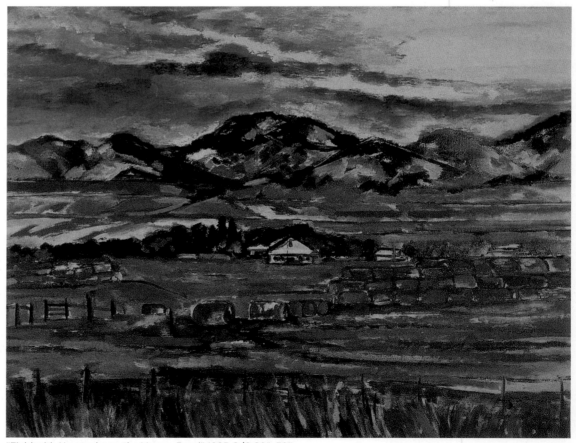

"Field with Haystacks on the Varney Road" 1995 O/C 60"x70"

"Round Montana Landscape"
2011 O/C Tondo

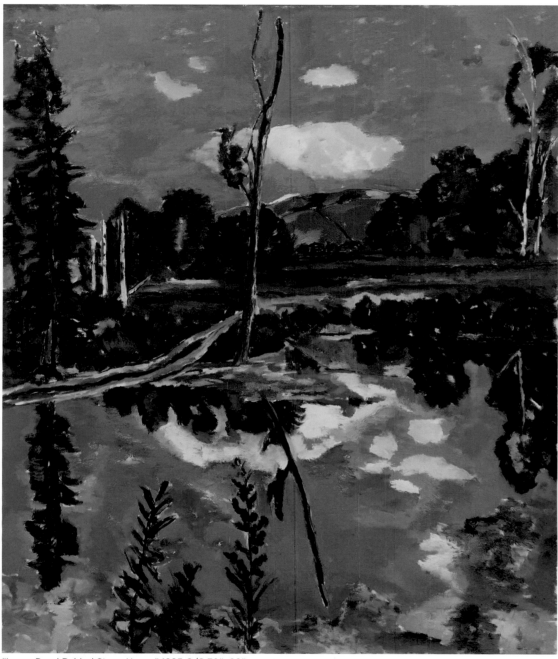

"Large Pond Behind Stone House" 1995 O/C 70"x60"

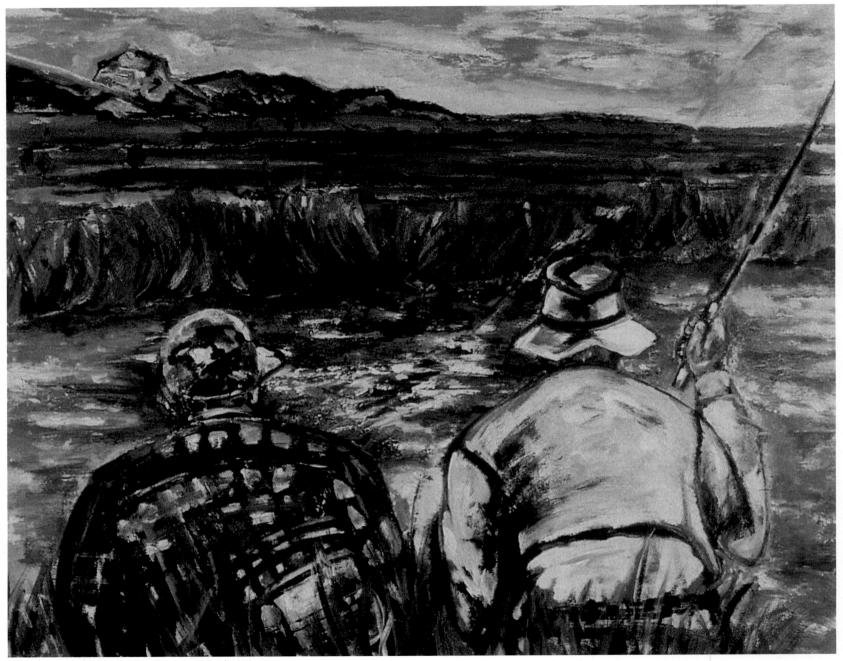

"Two Fishermen at Second Bend Pool" 1995 O/C 66"x70"

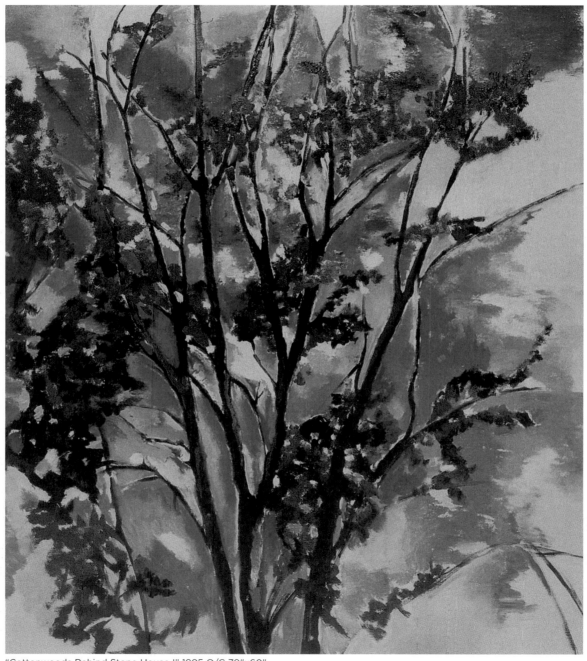

"Cottonwoods Behind Stone House I" 1995 O/C 70"x60"

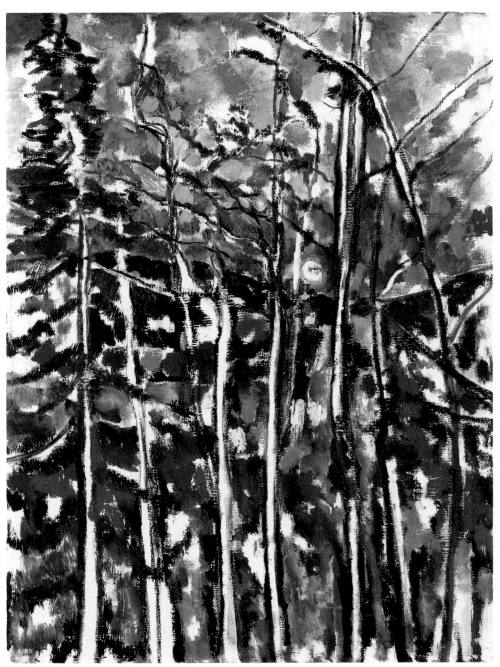

"Hillside-Sunset" 2010 O/C 79"x36.5"

Woodstock Landscapes

THE HILLSIDE BEHIND MY Woodstock studio is an inauspicious motif; it's a modest forest of ash, hemlock, and pine of different sizes, some slender, some wide, most tall—some rocks, a few large . . . sculpture like, most small. Things happen there—the light changes, now luminous, now stark; trees lean on other trees; trees fall and become skeletons of calligraphic lines. In the late afternoon sunsets light up the hillside, the vanishing light radiating hot pink and azure blue and a myriad of tones until the fall of darkness. Simple as the motif is it cannot be known—at least not by me. This small area—a microcosm—is as hard to possess as is a human form, and as difficult to know, in certainty. This is its fascination. I have worked on this motif on and off for more than a decade and I cannot grasp its infinite complexities. I have painted it—looking out from three large windows in the back of my studio space—in all seasons. Unlike the vast Montana spaces I painted in the 1980s, these landscapes are intimate, painterly, connected to an individual oak, a magnolia tree, a weeping cherry in the courtyard behind my studio, or a rock and trees on the hillside. This is the natural world that surrounds my studio—a world alive, filled with changing forms and colors, solid and in flux. My approach is not perceptual; I am not trying to paint what I see but rather to evoke the mystery of what is there by means of a structure and

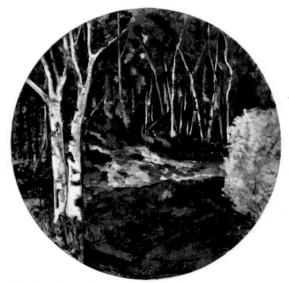

"Hillside with Two Birches and White Tree"
2005 O/C 44" dia. Tondo

color and line that exist parallel to nature. I want a respite now from using line as I have in my studio interiors, cityscapes, still lifes, portraits, and figures—to describe appearances. I hope that in these recent landscapes the question of whether they are realistic or abstract is irrelevant. I am here to compose paintings that are free, alive—meditations—and not to use line, as I have in the past, to enclose: I use color in patch-like juxtapositions, derived from Cézanne's color modulations—to create structure—so that the whole will burst forth from the line without boundaries, so that in its changeableness it forms an image like no other.

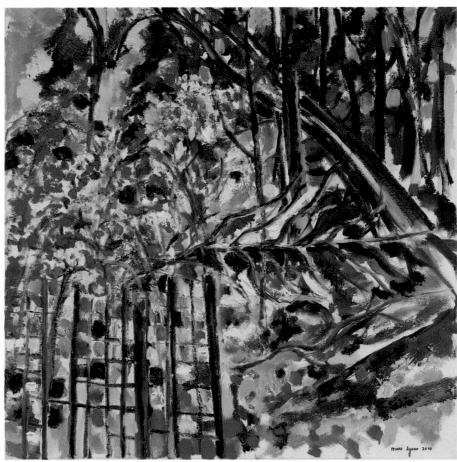

"Square Hillside with Fence" 2010 O/C 30"x30" *Rudolf Steiner School*

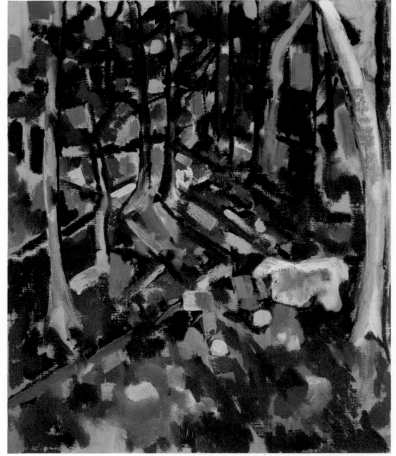

"Hillside with Rocks II" 2009 O/C 38"x32"

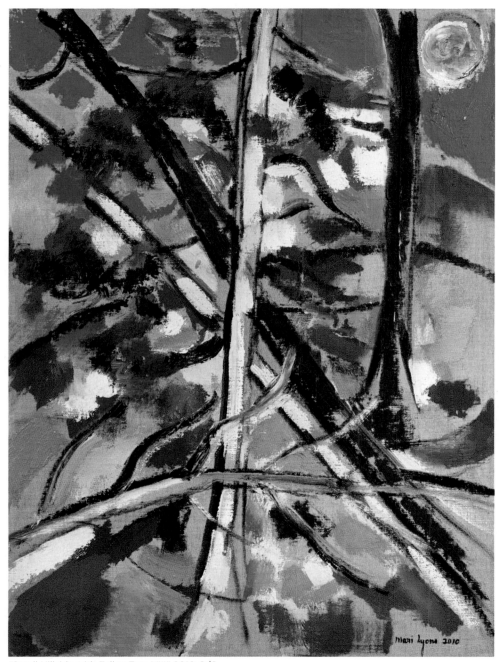

"Small Hillside with Fallen Tree VIII" 2010 O/C

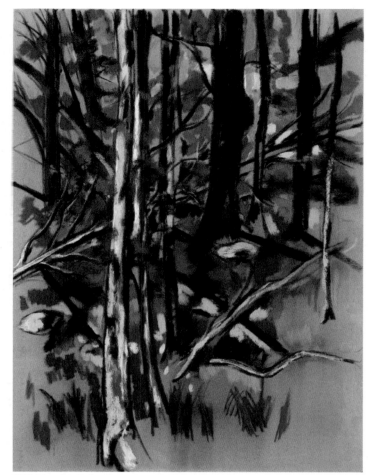

"Hillside with Fallen Branches II" 2010 Pastel on Paper 30"x24"

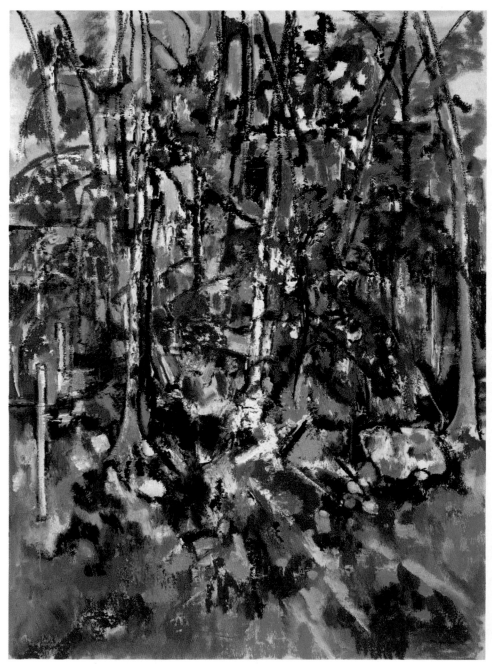

"Vivace II" 2010 O/C 78"x57"

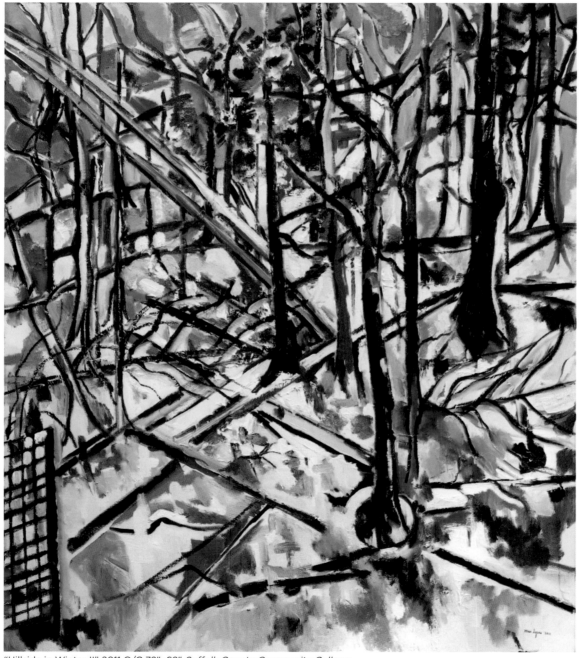

"Hillside in Winter II" 2011 O/C 72"x62" *Suffolk County Community College*

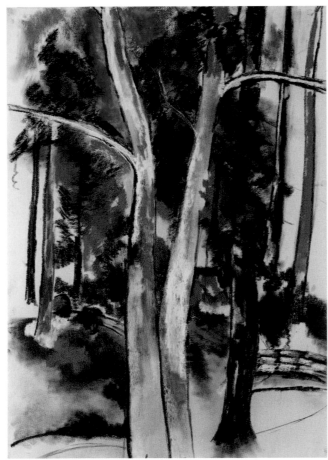

"Bare Oak in Fall" 2003 O/C 39"x27" *Suffolk County Community College*

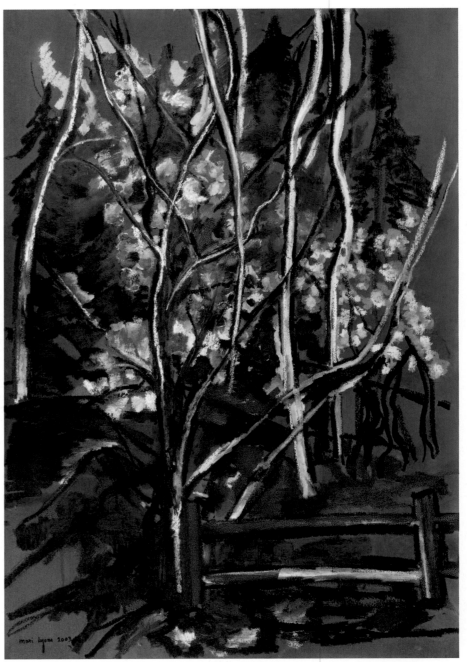

"Magnolia with Bloom" 2003 Pastel on Canvas 40"x29"

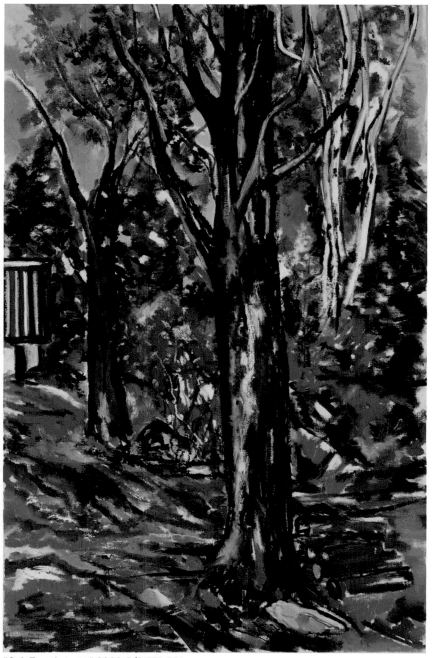

"Oak Tree Autumn" 2002 O/C 77"x50"

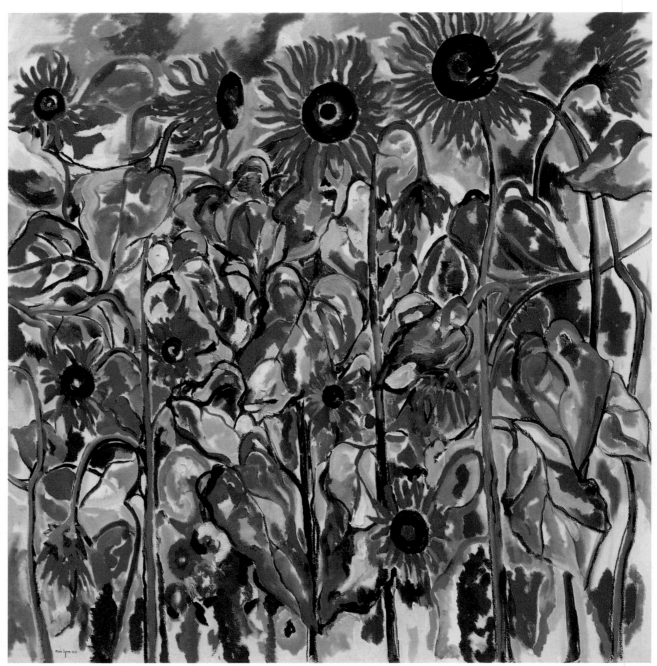

"Transformations" 2010 O/C 80"x83" *Bard College, Stevenson Library*

Transformations / Abstractions

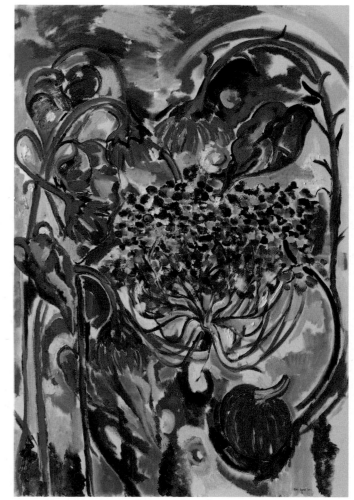

"Pumpkins and Dying Sunflowers" 2011 O/C 78"x53"

WHILE I WAS PAINTING my Interiors and Palette series, I also began a series focused on the transformations of elements of nature into more abstract forms. The first of these concerned the large painting of sunflowers, in which the flowers are themselves but are in the process of metamorphosing into a more elemental form. In many ways I have been doing this for many years—pushing the seen object into some degree of abstraction.

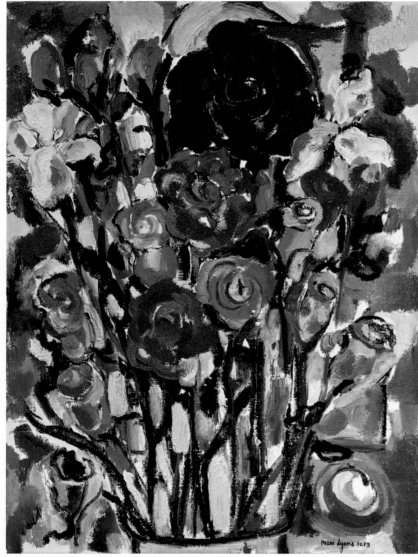

"Exploding Bouquet" 2013 O/C 25"x19"

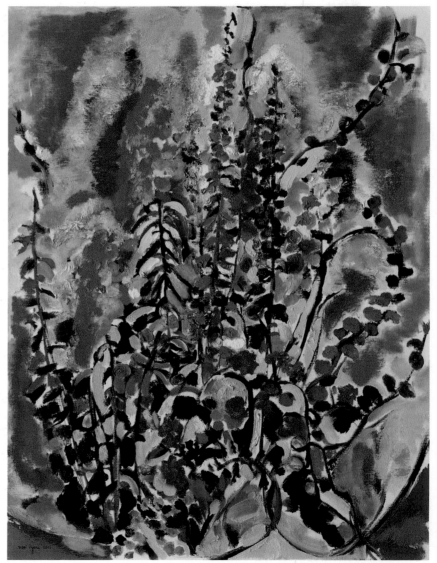

"Garden Abstract with Tall Plants" 2011 O/C

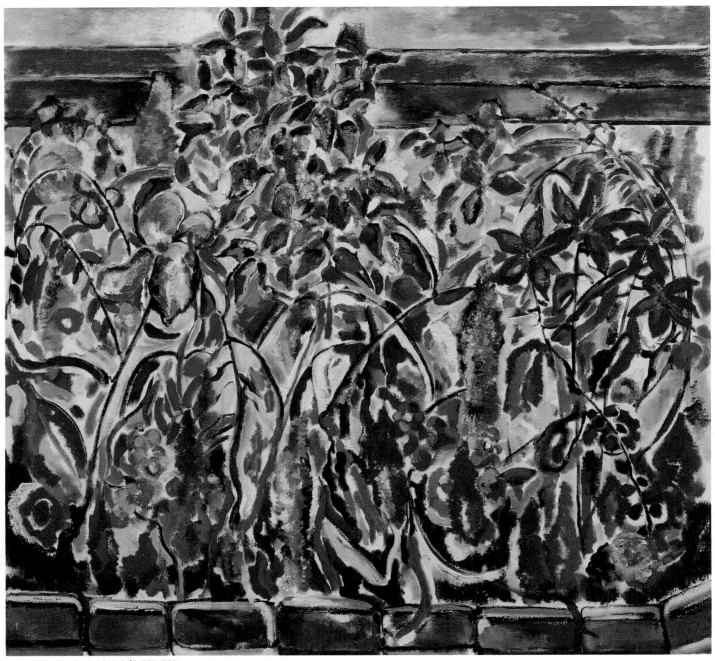

"From the Garden" 2012 O/C 72"x78"

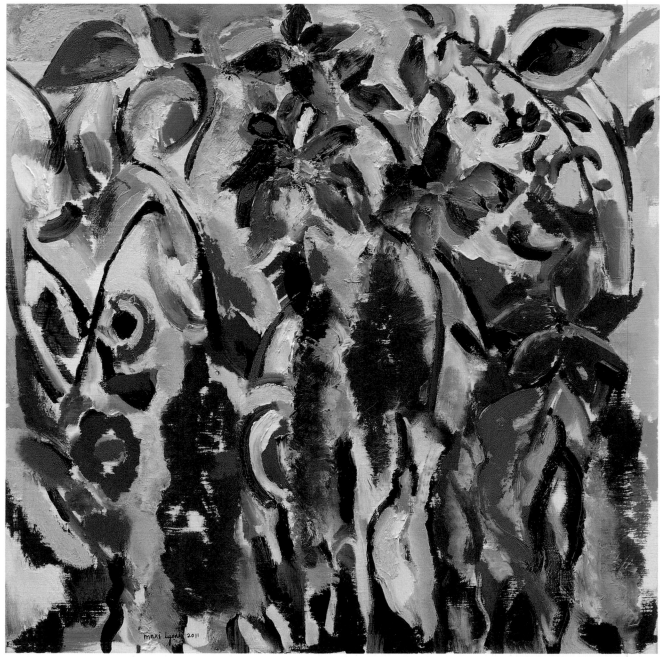

"Garden Abstraction VI" 2011 O/C 60"x72"

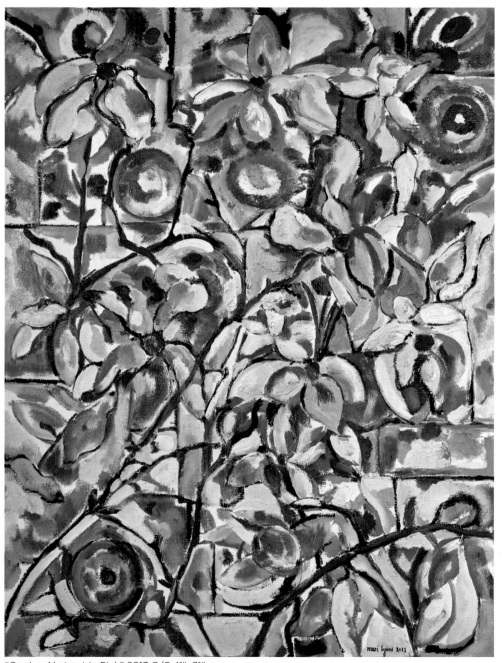

"Garden Abstract in Pink" 2013 O/C 41"x31"

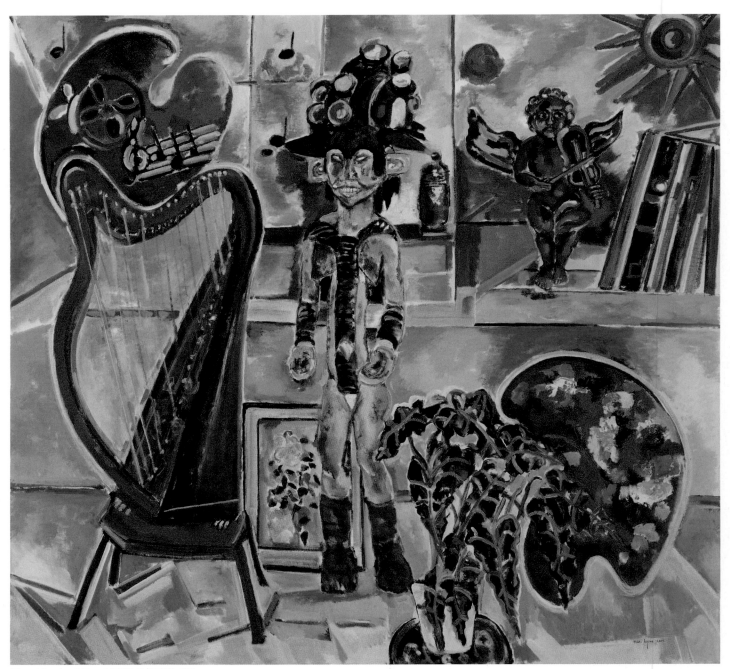

"Geraldine and Harp" 2015 O/C 70"x77"

My Late Interiors /
Floating Palettes

IN THESE PAINTINGS I borrow an image, a sign, from the late magical studio paintings of Georges Braque—with a nod, too, to the floating world of the Japanese ukiyo-e print. In Braque's metaphysical studio interiors, objects are transformed into towering events over which palette and bird float. He reinvents perceptual space. The painter, he writes in his notebook, does not try to "reconstitute an anecdotal fact, but to constitute a pictorial fact."

For several years I have used objects—some real, some imagined—in my studio, to explore (for me) new spaces and to invite in, often under the sign of the palette, the stars as they float in my imagined world as they interact with objects that I have brought to my "real" world, the world of my studio spaces. Some of these objects, subjects, are an Ibibio sculpture (nicknamed "Geraldine"), my carousel horse (the subject of many paintings), my African rooster, a wooden copy of an eighteenth-century angel, casts from the ancient Greek, and all the paints, brushes, paintings, vases, bottles, easels, things that line every artist's studio. The sculpture, the horse (sometimes looking for his pole), rooster, angel, and "Geraldine" were made by artists who carved them and imputed to them their own spirit; I have used them as a bridge to form mine. In these I meditate on the ever forming and floating language of

painting in the dramatic world of a studio and combine all the genres in which I have worked.

Some of these paintings are more objective, some more subjective. Some are more figurative and in some the figurative bleeds into abstraction (based on easel forms, palette forms, brush forms, and the like); still other paintings are almost purely abstract. I have a restless eye. All of these works are an attempt to anchor "floating space" into a bold and believable celebration of the act of painting and to embody the world of my studios, places that are the world I inhabit, that I have reimagined with great affection.

[August 2015]

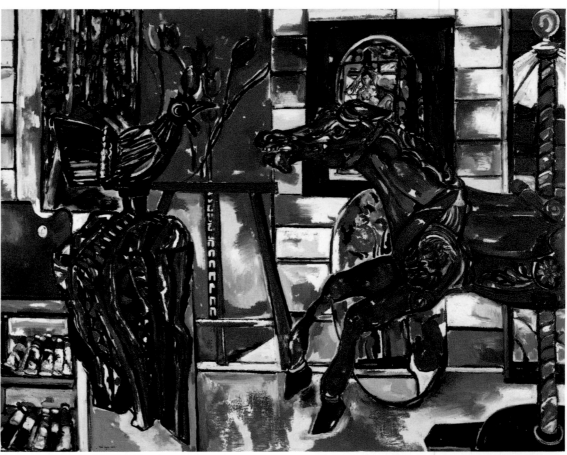

"Horse and Rooster" 2013 O/C

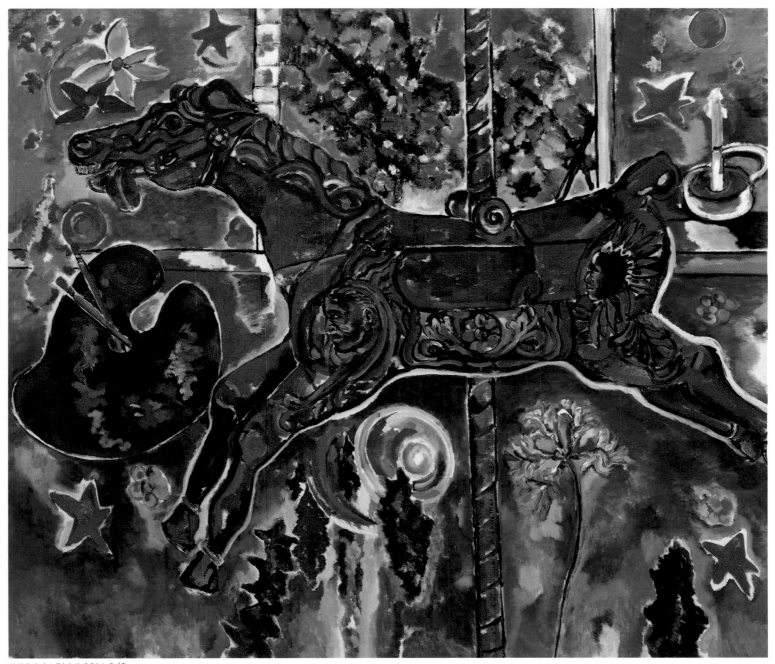

"Midnight Ride" 2014 O/C

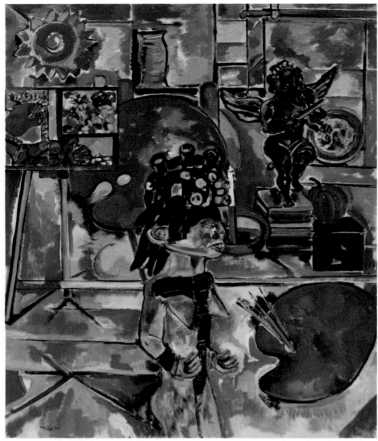

"Geraldine, Palettes and Studio" 2015 O/C 70"x60"

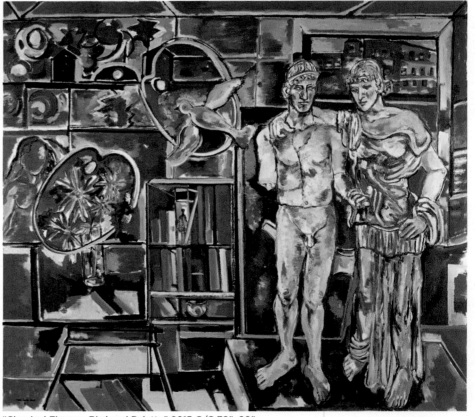

"Classical Figures, Bird and Palette" 2015 O/C 70"x80"

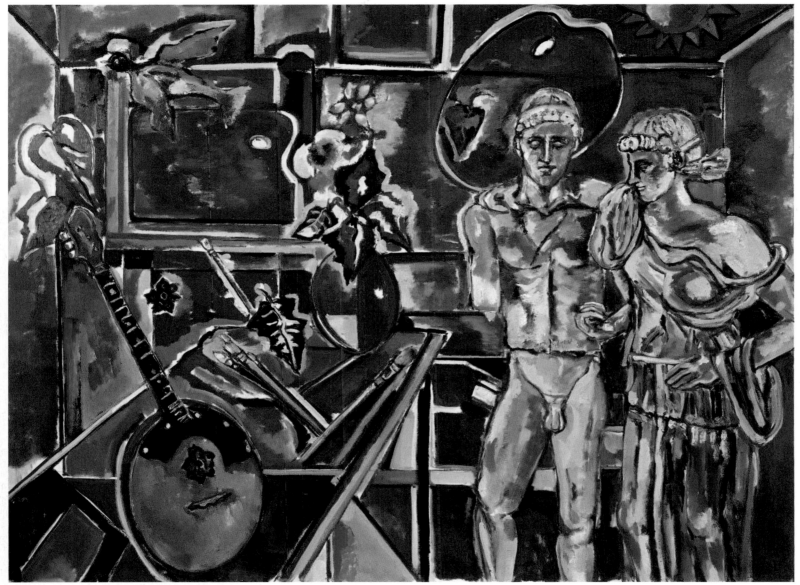

"Statues with Lute" 2014 O/C 70"x80" *Richmond College*

Early Work

"Early Landscape" 1948 O/C

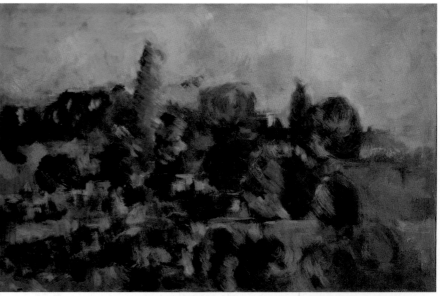

"New England Landscape III" 1955 O/C 32"x42"

"Abstract Landscape V" 1956 37"x28"

"Abstract Landscape IX" 1956 O/C

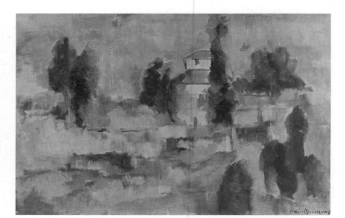

"Steeple Landscape" 1955 15"x24"

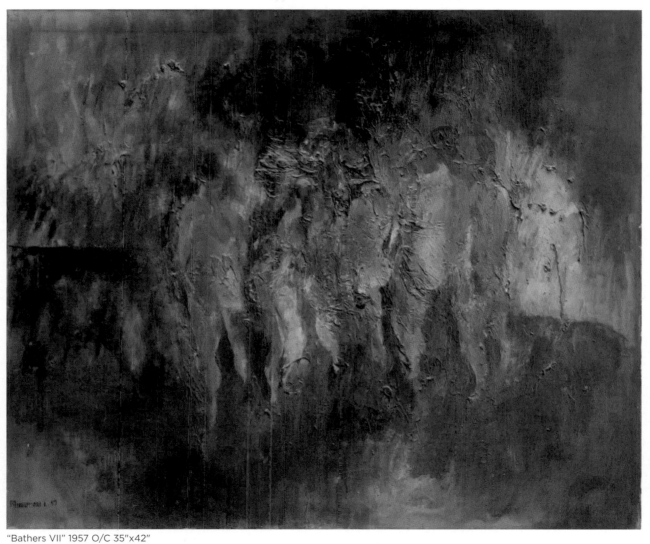

"Bathers VII" 1957 O/C 35"x42"

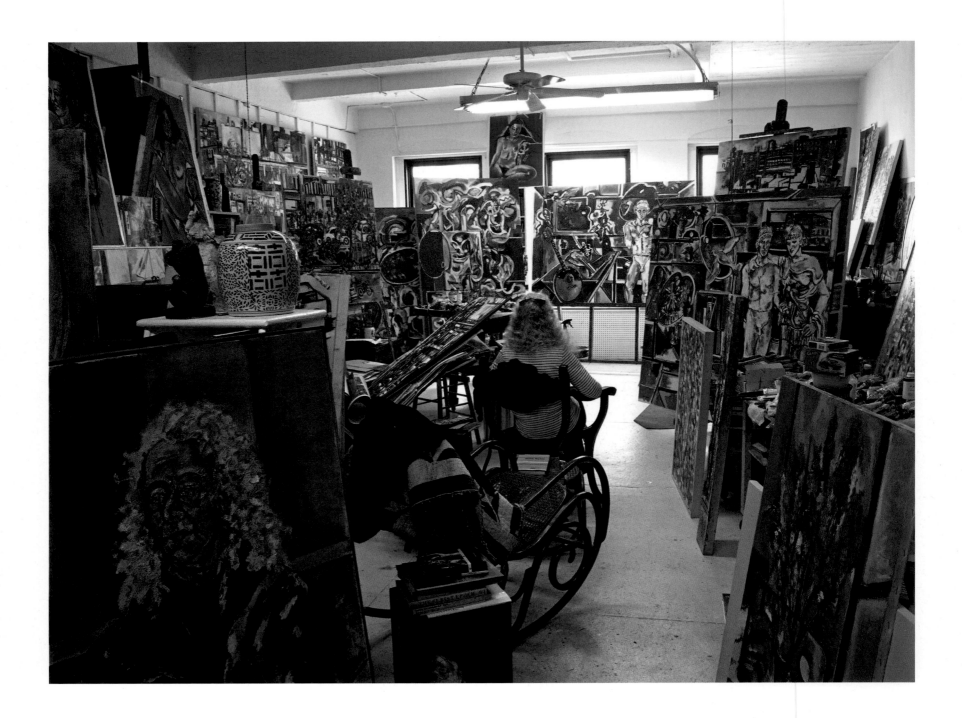

ACKNOWLEDGMENTS

This book took many years and much help from others to bring together. I'm grateful to those who made it possible: Liz Driesbach, who designed so many of Mari's invitation cards and brochures, and posters over the years, and for much help on all technical matters related to the photographs. John Goodrich, Nancy Donskoj, and Ralph Gabriner for most of the photographs herein. Jess Nickerson for invaluable studio help and storage management. Ruth Wetzel for years of extraordinary help, arranging, transporting, advising, and studio management in New York City and Woodstock. Kristin Crawford for typing, editing, and wise counsel and support in the preparation of this and previous texts. Bonnie Thompson for her always expert copyediting. Deborah Rosenthal, great friend, who read and gave invaluable advice on sections of the text at a crucial early stage. My daughter Jenny, deft literary agent, for so much support and advice for this and previous books. Tony for facilitating publication of this book.

Special thanks to Charlie Lyons for immense help preparing the website for Mari's work, managing the donations and sales in recent years, and solving so many of the problems finding and securing photographs and their identification, Michael Orsini, a latecomer to those helping, but providing excellent help for archival work and management of the studio. Ruth Garbus, for her love and support of me and of this project in recent years. Jed Perl was the first of several critics to write wisely about Mari's work in *The New Republic* and elsewhere—and to provide his warm and intimate essay for this book. I thank you all, and others, for helping when—as I approach ninety—I needed help.

MUSEUMS, COLLEGES, FOUNDATIONS, AND HOSPITALS THAT OWN PAINTINGS

Bard College • Dartmouth-Hitchcock Medical Center • American Museum of Fly Fishing • Borough of Manhattan Community College • Montana State University Library • Russell Sage College • Reynolds Community College • Montana Museum of Art and Culture • The Rudolf Steiner School • The New York State Museum • Museum of the City of New York • Mills College • Rider University • Montana Historical Society • Richmond College, University of Richmond • Wellesley College • Suffolk County Community College • DeGolyer Library, Southern Methodist University • Waldorf School • The Writers Room • Hobart and William Smith Colleges • University of Minnesota Health Sciences Education Center • Art Institute at the Arizona-Sonoma Desert Museum • Climate Central Foundation • Wyoming State Museum • Montefiore Medical Center • Northeastern Nevada Museum • Holter Museum of Art • BYU Museum of Art • National Spine Research Foundation • Childrens' Hospital Colorado

For more information about Mari Lyons see

www.marilyonsstudio.com